PHOTOGRAPHING
OREGON

with professional results

by Bryan F. Peterson

Graphic Arts Center Publishing Company
Portland, Oregon

To Valerie and Justin
my sources of inspiration.
BRYAN F. PETERSON

International Standard Book Number 0-912856-90-4
Library of Congress Catalog Number 84-080434
Copyright © 1984 by Graphic Arts Center Publishing Company
P.O. Box 10306, Portland, Oregon 97210 503/226-2402
Design: Robert Reynolds
Typesetting: Paul O. Giesey/Adcrafters
Printing: Graphic Arts Center
Binding: Lincoln & Allen Company
Printed in the United States of America

Contents

INTRODUCTION

Oregon presents the photographer — expert or novice — a compelling assortment of majestic, basalt gorges, vivid floral displays, wildlife, crystal waterfalls, sculpted agricultural lands, high desert terrain, and a rugged, misty coastline. Oregon is home to cowboys and computer whizzes, to skydivers and skiers, to homemakers, handymen, and hardy souls of all descriptions. What they have in common, besides addresses in Oregon, is photography. Beautifully, and badly, they *do* take pictures. Ninety-eight percent of all Oregonians own at least one camera. Visitors rate Oregon above average as a scenic state, and they often photograph the scenes as well as their families while touring throughout the state. For some, photography beckons because of the artistic expression it allows; for others, because of its immediacy and realism. For each of us, a photograph is a precious, frozen moment, preserving a special place, a special pleasure or, most often, special people.

There's a happy anticipation in waiting for a roll of film to be processed. Sometimes, alas, the shots you get just aren't what you had hoped for. With any luck, this book will help reduce the number of disappointments — through technical information and easy-reference listings of locations where my tips and your new techniques can be put to use. By no means do the photographs I've included indicate the *right* way to deal with each subject; rather, each indicates the interpretation I chose for that scene at that moment. This is more a sharing of ideas and experiences, and how I've approached them photographically.

The elements that go into a photograph — line, pattern, texture, form, hue, and shape — are considered here; but it will be your individual response which determines whether you'll turn them into a fine photograph. It will be you who chooses a lens and point of view; determines a range of tones and mood via exposure; and, after a long wait or perhaps in instant response, presses the shutter at that critical, *decisive moment*. The book is not limited to users of 35mm single lens reflex cameras; those of you with 110, 126, or fixed lens cameras should find it a valuable resource, as well.

As a travel guide, the book should help you avoid wasting time and energy — through listings of locations, recommended time of year, hours of the day, and desirable weather conditions for shooting particular subjects. Having a specific shooting theme in mind, I've found, tends to keep the photographer alert. The demands of a theme lend his or her

photography increased focus. But go ahead, by all means; shoot other subjects along the way. En route to the St. Paul Rodeo in July, you'll find orchards and oak trees; around Mount Hood in August, stop for wildflowers and mountain lakes; and heading toward the Coast in October, let yourself be seduced by broad expanses of autumn foliage and close-ups of mysterious mushrooms on the forest floor.

Much of Oregon remains unclaimed photographic territory. Even the well traveled road offers fresh perspectives. The landscape is in constant change. Should it ever seem there is nothing to shoot, it's not the fault of weather, lighting, or subject matter but, rather, the fault of a photographer who, at that moment, just isn't seeing creatively.

If readers feel inclined to duplicate my style or approach, no problem. I'm convinced that attempts to duplicate usually lead to new discoveries and, often, improvement.

I sincerely hope this book will demonstrate that Oregon offers vast and varied photographic resources. I will have succeeded if you find yourself making excuses for spending so much time shooting rather than explaining why you're not. Enjoy!

Bryan F. Peterson

The Technical Information Center referred to in the **Exposure** sections is located on pages 81-93 at the end of this book.

THE COAST

If any of Oregon's faces constitute a photographer's paradise, it's her coastline, one of the most beautiful in the world. I know of no place along the Coast where one cannot stop the car and, within minutes, begin to record exquisite vistas. Add to her beauty her 300-plus miles of public access — *photographers'* access — and she's all yours. Consider the wealth of subject matter: peaceful lighthouses and sheltered harbors, sea lions and sandpipers, fishing boats and foamy surf. For close-ups: starfish, seashells, sand patterns, seaweeds, and semi-precious stones. For long shots: mysterious offshore rocks, wind-sculpted pines, complex patterns of cliffs and tidepools. For the human touch: surf fishermen, children, and the continuous parade of serenely plodding, bending beachcombers. And, at the end of each day, there's always another, absolutely unique Pacific sunset — a timeless and irresistible temptation to artists and photographers, worldwide.

SUNSETS

Some photographers shoot sunsets with a wide-angle or normal lens, while others choose the telephoto. Some use colored filters, and others use cross-star or multi-image filters. As a judge in numerous photo contests, I've found that most entries in the landscape category tend to be of sunsets along the Coast, but they rarely win. Why? Because they lack exciting composition, or proper exposure, or both. To get memorable sunset shots, you may need to change your point of view, moving in closer to interesting foreground subjects.

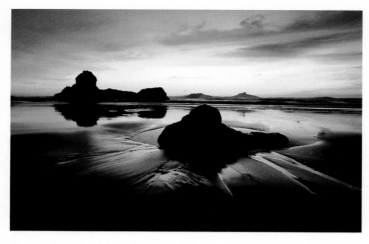

Opportunity A low tide providing wet sand and small pools to catch reflections.

Point of view and lens choice Kneel and move in close to the rocks and expanses of wet sand. This use of foreground interest creates depth. The 28mm, 24mm, or 20mm wide-angle lens provides the best shots, but the 50mm normal lens can be used as well.

Exposure Use a small lens opening, f/16 or f/22, to sharpen the whole scene. Pre-set your focus according to the depth-of-field scale on your lens. See Technical Information Center. Adjust the shutter speed for a correct exposure according to the light in the sky above the setting sun or to the light reflected in the wet sand in the foreground. If your camera has no manual exposure control, set the auto-exposure override to +1½ or 3X.

Film Choice 100 ISO, color print; 100-64-50, color slide.

Additional tips

- For foreground interest, use a high horizon line — at least the upper third of the photograph.

- Use a thirty-gallon plastic garbage bag to keep you dry on the wet sand.

- If you have a U.V. or skylight protective filter on your lens, make certain that it is clean. A dirty filter causes flaring.

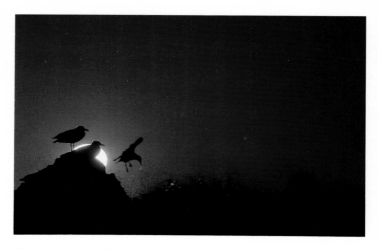

Opportunity The many birds among the offshore rocks at low tide.

Point of view and lens choice Whether you have to climb high, kneel, or stand at eye-level to your subject, photograph the birds against the sky or sun. Do not shoot them against the ocean waves; they will be lost. Use a telephoto lens of at least 135mm. I prefer a 200mm and 300mm.

Exposure If the birds are perched, set the aperture to f/16 or f/22. Adjust the shutter speed for a correct exposure according to the light in the sky to the left or right of the setting sun. If the birds are landing or taking off, set the shutter speed first to 1/250-second. Then adjust the aperture for a correct exposure according to the light in the sky to the left or right of the setting sun. If your camera has no manual exposure control, set the auto-override to +1 or 2X.

Film choice 100 ISO, color print; 100-64-50 ISO, color slide.

Additional tips

- To avoid possible damage to the eye while focusing into the sun with a telephoto lens, set the aperture to the smallest lens opening, f/22 or f/32, and press the depth-of-field preview button. This decreases the light transmission, making focusing and composing much easier. Note: Not all cameras have a depth-of-field preview.

- The use of winders or motor drives can be a valuable aid when photographing birds landing or taking off.

- If you're using protective filters, make certain that they are clean. A dirty filter causes flaring.

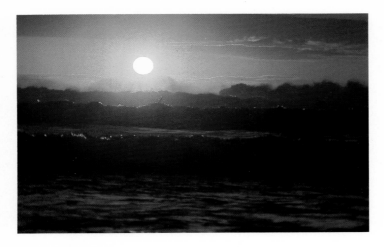

Opportunity Sunsets at high tide.

Point of view and lens choice Shoot the waves at their level. Use a telephoto of at least 135mm; I prefer 200mm.

Exposure Set the shutter speed to the 1/125-second and adjust the aperture according to the light on the sky to the left or right of the sun. If your camera has no manual exposure control, set the auto-exposure override to +1 or 2X.

Film choice 100 ISO color print; 100-64-50 ISO, color slide.

Additional tips

■ If you must wade into the water to fill the frame, watch for waves. When you are photographing breakers, position the horizon line near the upper third of the frame.

■ For maximum impact, shoot just as the uppermost wave begins to break.

■ If you're using U.V. or skylight protective filters, make certain that they are clean. A dirty filter causes flaring. Note: Because this is a simple composition, any beach serves as good subject matter.

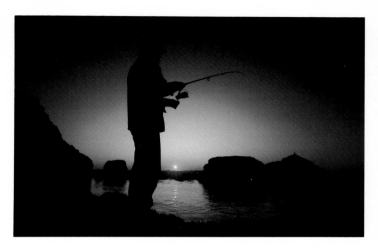

Opportunity Silhouettes of people taken during or a few minutes after sunset.

Point of view and lens choice If you squat or kneel when shooting your subject, the sky will provide a colorful background. When you stand at eye-level to your subject, part of your subject may become lost in the ocean. A wide-angle lens takes in more sky, but it also makes the sun smaller. The telephoto makes a bigger sun but reduces the amount of sky.

Exposure As the sun goes down, set the aperture to f/8 on the wide-angle or normal lens, and adjust the shutter speed until a correct exposure is indicated. An aperture priority camera will set the correct shutter speed for you. With a telephoto, set the aperture to f/16. Adjust the shutter speed for a correct exposure according to the light in the sky to the left or right of the setting sun. When shooting a few minutes after sunset, set the aperture to f/4 on the wide-angle or normal lens, and to f/8 on the telephoto. Adjust the shutter speed so it registers one-stop over the exposed reading, then shoot. If your camera has no manual exposure control, set the auto-exposure override to +1 or 2X during sunset and +2 or 4X after sunset.

Film choice 100-200 ISO, color print; 100-64-50 ISO, color slide.

Additional tips

- Before you shoot, make certain the horizon line is straight.

- Because shutter speeds may be too slow to hand hold, use a firm support such as driftwood or a tripod when shooting silhouettes after sunset. Your subject must stand absolutely still.

- Do not place your subjects against offshore rocks. You may be able to see the separation between them, but your exposure will not. Your subject will disappear into the dark rocks.

Good shooting locations (low tides)

Haystack Rock	At Cannon Beach two-thirds of a mile west of US 101
Haystack Rock	At Pacific City, west of US 101 via Three Capes Scenic Loop
Road's End Wayside	North end of Lincoln City on Logan Road
Moolack Beach	North of Newport near Yaquina Head on US 101
Seal Rock State Wayside	At Seal Rock, ten miles south of Newport on US 101
Cape Perpetua	Three miles south of Yachats on US 101
Bandon State Park	Five miles south of Bandon on the Beach Loop
Cape Sebastian	Seven miles south of Gold Beach
Harris Beach State Park	North end of Brookings

WIND AND WAVES

Throughout the year, Oregon's cliffs and rocks withstand the turbulence of the North Pacific high tides. The most dramatic high tide shows are staged in the fall and winter, when gale force winds lift the waves as high as sixty feet and then drop them with a thunderous roar. It's not uncommon to witness waves leaping over US 101. Up and down the Coast, at waysides and parks, the photographer can find spectacular views of one of nature's most awesome — and dangerous — spectacles. Where warning signs are posted, believe them. Where there are no signs, exercise greatest caution for your safety and for the protection of your equipment.

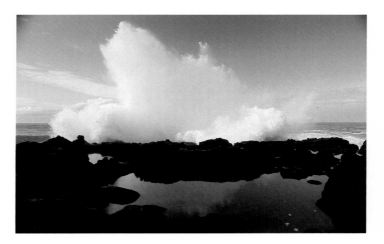

Opportunity During the morning hours the day *after* a gale. Billowing white clouds against patches of blue fill the sky, yet high tides and winds prevail. Shooting during the storm often is futile because the light in the sky is the same dull gray as the waves. You'll have trouble distinguishing between the sky and waves, not to mention keeping yourself and your equipment dry.

Point of view and lens choice Make personal safety your first concern. A safe spot is one where you can get the most action yet you can exit quickly should the need arise. Your lens choice depends on how close you can get to the action. When using a wide-angle lens or normal lens, get down low to pick up foreground interest. This helps give size and scale to the incoming breakers in addition to filling more of the frame with waves.

Exposure Set the shutter speed to 1/250 when the waves are breaking toward you, and to 1/500 or 1/1000 when they are breaking at an angle to you. Set the exposure with the aperture according to the light of the blue sky, or use the gray card in the back of this book. If your camera does not have a manual exposure control, set the auto-exposure override to +1½ or 3X.

Film choice 400-200-100 ISO, color print; 400-200-100-64 ISO, color slide.

Additional tips

- Shoot when the wave is at its peak of action. Using motor drives or winders can be a valuable aid.

- If you are near the end of your roll of film, and in between the action, change to a fresh roll. Better to lose a few frames at the end of the roll than to lose several frames of a spectacular crashing wave.

- Use U.V. or skylight protective filters to keep salt spray off the front lens element. Keep the filter clean in between shots.

- If a wave douses your lens or camera, immediately remove the batteries and film. Immerse the unit in a bucket of fresh water until you can reach a repair shop. Your equipment may never work again, but the chances for repair without taking this measure are zero.

- When you've finished shooting, give your equipment a complete wash-up with a damp sponge or washcloth, followed by a thorough wiping with a dry cloth.

Good shooting locations

Cape Kiwanda	The sandstone cape over the dune just north of the beach at Pacific City
Government Point	One mile north of Depoe Bay
Rocky Creek Wayside	Two miles south of Depoe Bay
Shore Acres	Off US 101, fourteen miles southwest of Coos Bay
Cape Perpetua	Three miles south of Yachats on US 101

SHORELINES AND TIDEPOOLS

Whether you find yourself at the beach on a cloudy day or a sunny one, a walk will reveal countless seaweeds, shells, feathers, driftwood, and sand patterns — all opportunities to put your close-up or normal lens to use. Continuing at low tide among the rocks and reefs, you'll find shellfish, anenomes, more seaweeds, textures, and reflections—each presenting yet a new and complex photographic challenge.

Opportunity The repetitive tides and winds, reshaping the sand into many patterns. The last half hour of daylight casts colors of gold to orange, emphasizing the texture and form of the sand.

Point of view and lens choice For best results, face into the light reflecting on the sand. To keep the frame limited to the sand pattern, use a telephoto or a telephoto zoom, or move in close with a normal lens.

Exposure Because you are facing the subject at an angle to the film plane, use an aperture of at least f/11 with a normal lens or f/16 with a telephoto lens. Adjust the shutter speed according to the light on the sand until a correct exposure is indicated. An aperture priority camera in automatic will set the correct shutter speed for you.

Film choice 100 ISO, color print; 100-64-50, color slide.

Additional tips

■ During the same half hour before sunset, close-ups of driftwood patterns are more exciting because of this added warmth of light.

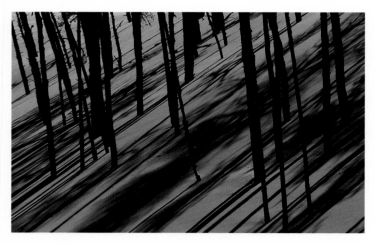

Opportunity Giant sand dunes between Florence and North Bend. The sidelight of early morning or late afternoon, when shadows are longest, emphasizes texture.

Point of view and lens choice Move in close or use a telephoto lens to fill the frame with the pattern of trees and shadow.

Exposure To attain sharpness throughout the whole scene, use an aperture of f/16 or f/22. For maximum depth-of-field, preset the focus according to the depth-of-field scale on the lens. See Technical Information Center. Adjust your shutter speed according to the light reflecting from the sand until a one-stop underexposure is indicated. If you don't have a manual exposure control, set the auto override to −1 or ½X.

Film choice 100 ISO, color print; 100-64-50 ISO, color slide.

Additional tips

■ If it is windy, do not set your camera bag on the sand. Keep it over your shoulder or place it on a stump or log.

■ To avoid getting sand inside the camera body, carefully change lenses or film with your back to the wind.

Opportunity A low tide revealing an abundant array of marine life among the reefs and rocks. An overcast or cloudy day provides equal light distribution.

Point of view and lens choice Move in close until you fill the frame. A wide-angle lens allows close focusing and captures more subjects. A normal lens can be used, but it limits detail. If you have close-up filters, macro converter, or extension tubes, you can use them with your normal lens to get much closer. The telephoto zoom with close focus or macro works especially well.

Exposure When shooting subjects that are parallel to the film plane, an aperture of f/8 is adequate. When subjects are at an angle to the film plane, use an aperture of f/16. Adjust your shutter speed according to the light reflecting from the scene until a correct exposure is indicated. An aperture priority camera in automatic will set the correct shutter speed for you. Note: When shooting subjects that are partially lit by sunlight, position yourself so that you cast an even shadow over the entire scene. This makes a correct exposure much easier.

Film choice 100 ISO, color print; 100-64-50 ISO, color slide.

Additional tips

- When shooting into tidal pools, use a polarizing filter to reduce the glare of the water's surface.

- When shooting subjects in open shade with slide film, use an 81-A warming filter to reduce the bluish cast.

Good shooting locations (marine life/tidepools)

Indian Head Beach	At Ecola State Park north of Cannon Beach, take three-mile trail
Cannon Beach	Two-thirds of a mile west of US 101
Moolack Beach	North of Newport near Yaquina Head on US 101
Seal Rock State Wayside	At Seal Rock, ten miles south of Newport on US 101
Marine Gardens	At Devil's Punch Bowl
Tidepool Preserve	At Cape Perpetua, three miles south of Yachats on US 101

HARBORS

Whether you simply seek variations of color and form, or have in mind a specific character portrait of a salty and seawise fisherman, you'll find pleasure boats and fishing fleets, entire marinas of differing moods and sizes. Fishermen unload their catches while seagulls wait for the day's scraps. Tying it all together visually are the nets, lines, rigging, and masts, each describing timeless forms of life and leisure by the sea.

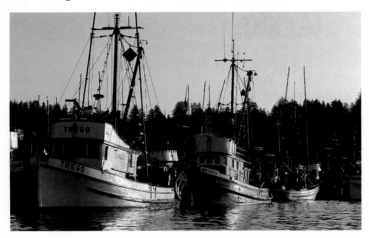

Opportunity Boats in the harbor. At this time the sidelight of early morning or late afternoon casts its warm glow on boats, emphasizing their shapes and textures and giving the scene depth.

Point of view and lens choice Get down low to meet the bow of the boats at eye-level. This fills the sky with masts rather than with cluttered backgrounds. Choose the lens by the number of boats you want to include. A telephoto lens gives you a few, while the wide-angle gives you many.

Exposure If all the boats are at the same focused distance, use an aperture of f/8. If the boats are at an angle to the film plane, use an aperture of f/16. Adjust your shutter speed for a correct exposure. An aperture priority camera in automatic will do this for you. If you want to retain detail in the shadows, set the exposure to one stop over. If your camera has no manual exposure control, set your auto-exposure override to +1 or 2X.

Film choice 100 ISO, color print; 100-64-50, color slide.

Additional tips

- When shooting with a wide-angle lens, use foreground interest, as an example, the bow of a boat, leading the eye into the rest of the scene.

Opportunity Portraits or candids of fishermen. The soft light of a cloudy day is kindest to the face since it does not show the lines and crevasses produced by the years at sea. On the other hand, sidelighting brings out the rugged and weathered nature of the subject. Early morning or late afternoon sidelight lends warmth.

Point of view and lens choice If you have a companion, ask him or her to talk to the fisherman. This distracts your subject and gives you the freedom to move around. Avoid cluttered backgrounds. Move in closely enough to fill the frame without invading the subject's boundaries. A 135mm telephoto lens works best and, in addition, reduces the angle of view to eliminate unnecessary nearby subjects.

Exposure Keep the aperture near wide open, f/5.6 or f/4, and adjust the shutter speed for a correct exposure. An aperture priority camera in automatic will do this for you. If you're shooting the subject in early morning or late afternoon sidelight, increase your exposure by one stop to retain detail in the shadow areas. If your camera does not have a manual exposure control, set the auto-exposure override to +1 or 2X.

Film choice 400-200-100 ISO, color print; 400-200-100-64 ISO, color slide.

Additional tips

- A tripod can get in your way and, more importantly, can intimidate your subject.

- When shooting slide film on an overcast day, use an 81-A warming filter to reduce the bluish cast.

- Focus on the subject's eyes, the most compelling part of the face.

- Consider shooting portraits of hands. They tell much about the history of an individual.

- When shooting a portrait, ask the subject to sit behind an open window or to stand in a doorway. Framing with such a frame adds impact to the composition.

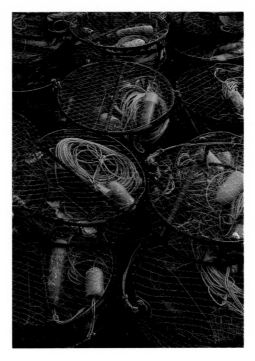

Opportunity Colorful crab traps and fishing nets along docks and on board boats. Choose a cloudy day.

Point of view and lens choice Position yourself so that nothing, for example, lines or masts, is between you and your subject. Create impact. Move in close, using a lens that fills the frame with your subject.

Exposure Because the frame is filled by subjects at or very close to the same focused distance, use an aperture of f/8. Adjust the shutter speed according to the light reflecting from the scene until a correct exposure is indicated. An aperture priority camera in automatic will set the correct shutter speed for you.

Film choice 100 ISO, color print; 100-64-50, ISO color slide.

Additional tips

- At sunset use a 200mm or telephoto zoom lens to silhouette seagulls perched on piers.

- A telephoto, 135mm or greater, isolates the colored abstracts of a boat reflecting on the water.

- When shooting in mid-day sun, use a polarizing filter to reduce the harsh glare from the brightly colored boats and from the bay's surface.

Good shooting locations

Astoria	Medium size harbor on the Columbia River on US 30
Depoe Bay	Small harbor on US 101
Newport	Large harbor just off US 101 at Yaquina Bay
Charleston Boat Basin	Large harbor eight miles southwest of Coos Bay

LIGHTHOUSES

Although every Oregon lighthouse presents a distinctly different sentinel mood, each seems to tell stories of storms and shipwrecks, fogs and fear, loneliness and longing — and homecomings. Because of their diverse locations and solitary nature, each presents a unique challenge. By shifting your point of view and using different lenses, you can easily create a broad collection of photographs of one lighthouse. As you make return trips to it, shooting under different seasonal and lighting conditions, your collection will take on even more depth and variety.

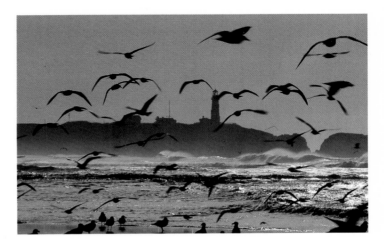

Opportunity Yaquina Head Lighthouse from Moolack Beach during winter when seagulls flock in great numbers. The south backlight of mid-day provides the best conditions for shooting, but the sidelight of sunset also works well.

Point of view and lens choice Kneel to bring more sky and seagulls in flight into your composition. Place the slim point of land where the lighthouse sits near the bottom third of the frame. Use a 200mm lens, or, better, a 300mm or 400mm. If you have a doubler, use it now.

Exposure Set the shutter speed to at least 1/125-second. This freezes the gulls in flight. Adjust your aperture to the bright light in the sky, until a correct exposure is indicated. A shutter priority camera in automatic will do this for you. This silhouettes the gulls and lighthouse. If your camera does not have a manual exposure control, set the auto-exposure override to −1 or ½X.

Film choice 100-200-ISO, color print; 200-100-64 ISO, color slide.

Additional tip

■ In general, avoid startling wildlife. Most gulls take to the air when people pass by.

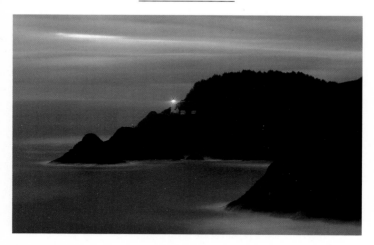

Opportunity Lighthouses up to one-half hour after sunset.

Point of view and lens choice The distance you stand from the lighthouse determines which lens you use. Whether you shoot from a point above or from the beach below, include both water and sky in your composition.

Exposure Choose an exposure time from the following tables: the longer the exposure, the greater the depth-of-field. You can record more wave action, giving a cotton-candy effect, with longer exposure times. Because the exposure times are approximate, bracket above and below the chosen exposure. For example: Shoot at f/11 for two minutes. Now take two more shots, one at f/11 for four minutes and one at f/11 for one minute. Every "long" exposure requires: a tripod or firm support; shutter speed dial set on "B"; a locking cable release; a stopwatch or a watch with a second hand.

ISO 64/100	**ISO 400**
f/5.6 for 30 seconds	f/5.6 for 8 seconds
f/8 for 1 minute	f/8 for 16 seconds
f/11 for 2 minutes	f/11 for 30 seconds
f/16 for 4 minutes	f/16 for 1 minute
f/22 for 8 minutes	f/22 for 2 minutes

Film choice 400-200-100 ISO, color print; 400-200-100-64 ISO, color slide.

Additional tips

- If you are using a horizon line, be sure it is straight.

- When shooting lighthouses with a telephoto against the setting sun, set the exposure according to the light in the sky to the left or right of the sun.

- Several of Oregon's lighthouses are topped by glass domes. For a dramatic shot, choose a point of view that places the setting sun directly behind the dome.

- To emphasize a lighthouse's strength and dignity, lie on your back at the base of the lighthouse and shoot a vertical composition with a wide-angle lens. Frontlighting further enhances this shot.

- A magnificent shot occurs on clear mornings once every month when the full moon sets on the western horizon. The sunrise to the east frontlights the lighthouse.

- During late spring and early summer, use flowers as foreground interest to lead the viewer's eye into the scene. A wide-angle lens works well.

- When shooting in mid-day sun, use a polarizing filter to reduce harsh glare from the landscape.

Good shooting locations

Cape Meares Lighthouse	At Cape Meares State Park on Three Capes Scenic Loop, ten miles west of Tillamook
Yaquina Head Lighthouse	One mile north of Newport on US 101
Cape Arago Lighthouse	Fourteen miles southwest of Coos Bay off US 101
Heceta Head Lighthouse	Six miles north of Florence on US 101

VALLEYS AND HILLS

Just outside Oregon's metropolitan areas, one finds greener photographic pastures. Orchards provide endless possibilities, regardless of season. Telling a similar story in different cadence are the barns — weathered and leaning, or freshly painted — with haystacks, balers, ploughs, and the requisite farm animals nearby. Meandering the backroads, from one farming community to the next, soothes the mind and unfolds the diversity of the valleys and hills.

BARNS, FARMYARDS, AND FIELDS

Because of their varied architecture, ages, colors, and settings, Oregon's barns continue to be a compelling, favorite subject of photographers. Barns make especially fine subjects for the four-season series — the same barn, shot from the same point of view, with the same lens, at each season. The surrounding fields and foliage, changing with the seasons, provide a near-motion, time-lapse effect for the stoic, motionless structure. Acres of berries, grain and hop fields, fruit orchards, vineyards, and nut farms beckon the photographer looking for pattern and form.

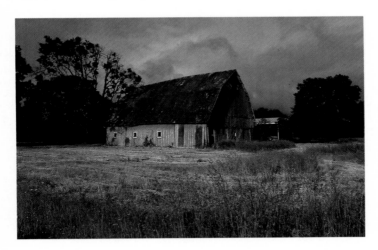

Opportunity The many barns throughout the Willamette and Rogue River valleys, as well as northeast Oregon. Frontlight or sidelight provide emphasis for details and textures.

Point of view and lens choice If you want to emphasize a barn's shape, shoot just one side. If you want to emphasize its form and give the scene depth, shoot it at an angle to include two sides. Use a wide-angle lens to shoot the whole barn from this perspective.

Exposure Use a small lens opening, f/16 or f/22, to sharpen the scene. For maximum depth-of-field, preset the focus according to the depth-of-field scale on the lens. See Technical Information Center. Adjust the shutter speed according to the light on the barn until a correct exposure is indicated. An aperture priority camera in automatic will set the correct shutter speed for you.

Film choice 100 ISO, color print; 100-64-50 ISO, color slide.

Additional tips

■ Consider shooting from low points of view with a wide-angle lens. A wheat or strawberry field in the foreground invites the viewer into the scene.

■ Barns with unobstructed views to the east or west make good silhouettes against a sunrise or sunset.

■ If you are permitted access to the property, use close-up equipment to record the beautiful abstracts created by weathered wood.

■ Find a barn with oak, maple, elms, or poplars growing nearby. As you return throughout the year, the tree marks nature's cycle of the seasons.

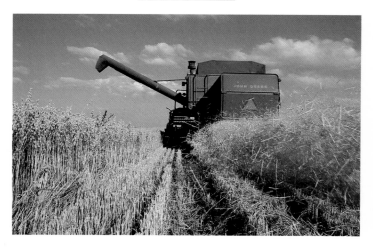

Opportunity The many activities taking place during the summer harvest. Frontlight best shows detail.

Point of view and lens choice Make it obvious that the harvest is under way. Shoot this activity full-frame. The complexity of the subject and the distance from which you are shooting determines lens choice.

Exposure Use a small lens opening, f/16 or f/22, to sharpen the scene. For maximum depth-of-field, preset the focus according to the depth-of-field scale on the lens. See Technical Information Center. Adjust the shutter speed according to the light reflecting from the whole scene. An aperture priority camera in automatic will set the correct shutter speed for you.

Film choice 100 ISO, color print; 100-64-50 ISO, color slide.

Additional tips

- In late July and early August, acres of wheat fields offer the landscape photographer unlimited access to agriculture at work. In early morning light you can include snow-capped mountains in the background. The telephoto when combined with a small lens opening of f/16 or f/22 makes the composition sharp, in addition to stacking the rolling hills.

- During the first two weeks of June, the strawberry harvest in the Willamette Valley is in full swing. Shooting a crate of berries full-frame or taking close-ups of the individual berries are two possibilities.

- During late May, crimson clover blooms turn the hills of Washington and Polk counties into a carpet of red.

- When shooting in the mid-day sun, use a polarizing filter to reduce the harsh glare.

- Cattle round-ups and branding of calves take place each spring in northeast and north central Oregon.

- The weather-worn faces of sunburned farmers and ranchers make excellent portrait subjects.

- Silhouette the combines or tractors against the sunrise or sunset.

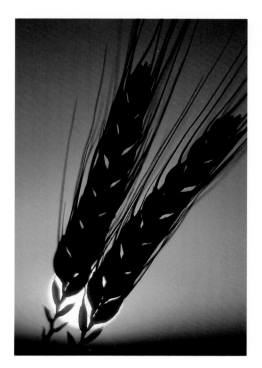

Opportunity Close-up of shocks of wheat taken at the first few minutes of sunrise or at the last minutes of sunset.

Point of view and lens choice Kneel to single out the shocks of wheat against the sunrise or sunset. For maximum effect, use whatever combination of close-up equipment necessary to fill the frame with wheat: a telephoto zoom lens set at close focus or macro; a normal lens with close-up filters; a macro converter; a set of extension tubes; or a macro lens.

Exposure Set the aperture to wide open, the smallest number. Any out-of-focus spot of light, such as the sun, will take on the shape of the aperture, a circle. Any other aperture will produce a hexagonal spot of light. As the sun rises or sets, the ball of light becomes more intense. Adjust the shutter speed according to the out-of-focus ball of light until a correct exposure is indicated. This always produces a silhouette of the focused object. Note: If your shutter speeds cannot provide a correct exposure, don't stop the lens down. Use a neutral density filter to reduce light transmission.

Film choice 100 ISO, color print; 100-64-50-25 ISO, color slide.

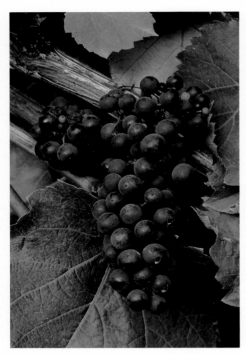

Opportunity In late September, the grape clusters in the vineyards from the Willamette Valley south to Roseburg. Choose an overcast or cloudy day when the light is equally distributed.

Point of view and lens choice Meet the grapes at their level. A normal lens works well as does a short telephoto or telephoto zoom. Shoot the subject full-frame.

Exposure Even though the grapes and leaves are at approximately the same focused distance, use a small lens opening, f/16 or f/22, to sharpen the scene. The closer you focus, the more shallow the depth-of-field. Adjust the shutter speed according to the light reflecting from the grapes until a correct exposure is indicated. An aperture priority camera in automatic will set the correct shutter speed for you.

Film choice 100 ISO, color print; 100-64-50 ISO, color slide.

Additional tips

- On most weekends the vineyards are open to the public, although you should call ahead to check. Owners generally do not prohibit photographing.

- With proper close-up equipment, fill the frame with grapes only and create an impression of colored balloons.

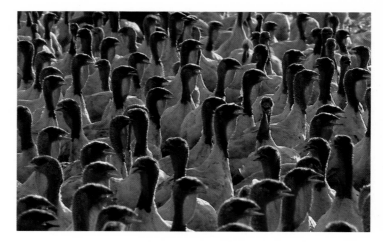

Opportunity Flocks of turkeys, herds of cattle, horses, or sheep. This powerful composition is referred to as "the masses," and is one commonly overlooked both by amateurs and professionals.

Point of view and lens choice Whether you meet your subject at its level or climb above to shoot, try to fill the entire frame with birds or animals. The number of subjects and their size determines the proper lens choice, but the telephoto or normal lens is my choice. Because the turkey's red waddles are transparent, position yourself to take advantage of the backlight.

Exposures When stacking subjects with the telephoto, use an aperture of f/16 for sharpness front to back. When metering a backlit scene in which the sun is not part of the composition, adjust the shutter speed to one stop over exposure. If your camera has no manual exposure control, set the auto-exposure override to +1 or 2X.

Film choice 100 ISO, color print; 100-64-50 ISO, color slide.

Good shooting locations

Numerous opportunities present themselves throughout the valleys on both sides of the Cascades. Ask permission to cross private land.

Willamette Valley (excellent farms)	Between Portland and Eugene, along Hwy. 99W and other rural roads parallel to I-5
Tualatin Valley (farms)	Hillsboro region along Hwys. 8 and 47
Rogue River Valley (orchards and farms)	Grants Pass region off I-5
Hood River Valley	South of Hood River along Hwy. 35
Enterprise region	Along Hwy. 82
La Grande region	North of La Grande along Hwy. 82

ORCHARDS

In the spring, Oregon's apple, pear, peach, and plum trees stage a lush show of blossoms. In summer, their branches bend, heavy with rich fruits ranging in color from deep, dusky plum tones through delicate shades of peach. Apples and cherries range from deep reds through startling yellows. Cool, crisp fall mornings turn their leaves into the full range of New England-style fall foliage colors. Also in the fall, the filbert and walnut orchards offer different challenges and opportunities for catching subtle ranges of earth tones and textures. With winter's first snowfall, each orchard's pattern is suddenly, starkly, and dramatically revealed, ready for a completely different photographic treatment.

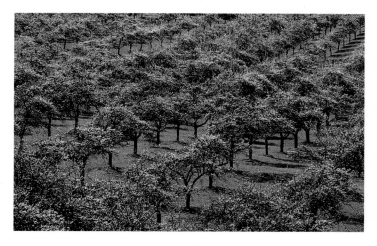

Opportunity Spring blossoms. Overcast days provide better lighting than do sunny days because the light is equally distributed.

Point of view and lens choice Shoot from a point above the orchard. This allows you to illustrate and emphasize the orchard's pattern and design. While a normal lens can work, I prefer a 135mm telephoto lens or even greater.

Exposure The normal lens set to an aperture of f/8 is adequate. With a telephoto, use an aperture of f/16. Adjust the shutter speed according to the light reflecting from the scene until a correct exposure is indicated. An aperture priority camera in automatic will set the correct shutter speed for you.

Film choice 100 ISO, color print; 100-64-50 ISO, color slide.

Additional tips

- A bee on a blossom makes a good subject, as does the blossom alone.

- Lie on your back and shoot up with a wide-angle lens into a blossoming tree.

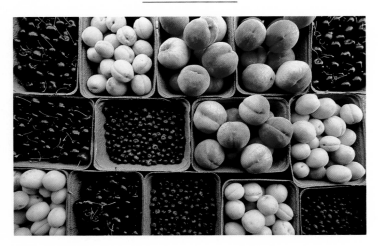

Opportunity Orchard harvest. Fruit stands along the back roads and major highways offer opportunities for still lifes. Shoot in shade or in the light of an overcast day.

Point of view and lens choice Shooting straight down on the basket of fruit records a colorful pattern. The number of baskets you include determines whether you need a wide-angle or normal lens. Shoot the subject full-frame.

Exposure The closer you focus the more shallow the depth-of-field becomes. Use an aperture of f/11 or f/16. Adjust the shutter speed according to the light reflecting from the scene until a correct exposure is indicated. An aperture priority camera in automatic will set the correct shutter speed for you.

Film choice 100 ISO, color print; 100-64-25 ISO, color slide.

Additional tips

- If you're shooting a sidelit still life and want to record detail in the shadows, set the exposure to one stop over the indicated reading. If your camera has no manual exposure control, set the auto exposure override to +1 or 2X.

- Shoot still lifes against uncluttered backgrounds.

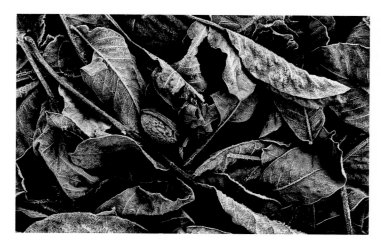

Opportunity Crisp autumn mornings when the orchard floor provides a variety of close-ups. Sidelighting calls attention to the subject's texture and shape.

Point of view and lens choice For uniform sharpness, shoot straight down so that the subject is parallel to the film plane. You may use a normal lens, but I recommend for close-ups a zoom lens with close focus, close-up filters, extension tubes, a macro-converter, or a macro-lens.

Exposure For maximum sharpness, use f/11 or f/16. Adjust the shutter speed according to the light reflecting from the scene until a correct exposure is indicated. An aperture priority camera in automatic will set the correct shutter speed for you.

Film choice 100 ISO, color print; 100-64-50 ISO, color slide.

Additional tips

- Similar scenes occur in filbert and apple orchards: A lone filbert struggles for the last rays of sun through frost-covered leaves; an abandoned red apple gains comfort from a blanket of leaves.

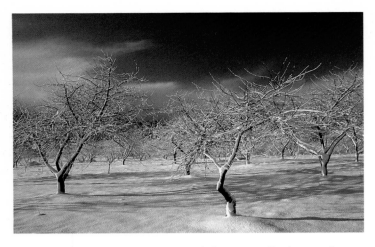

Opportunity Winter's first snowfall pattern. Early morning or late afternoon frontlighting is ideal.

Point of view and lens choice The age of the orchard determines whether you shoot at eye-level or from a kneeling position. Your goal is to contrast the orchard against the blue sky. The wide-angle or normal lens brings together the most trees.

Exposure Use a small lens opening, f/16 or f/22, to sharpen the scene. For maximum depth-of-field, preset the focus according to the depth-of-field scale on the lens. See Technical Information Center. Adjust the shutter speed for correct exposure according to the light in the blue sky. If your camera has no manual exposure control, set the auto-exposure override to +1 or 2X.

Film choice 100 ISO, color print; 100-64-50 ISO, color slide.

Additional tips

■ At mid-day in an orchard, use a polarizing filter to reduce the harsh glare.

Good shooting locations

Hood River Valley (apple and pear trees from mid-April to early May)	South of Hood River along Hwy. 35
Rogue River Valley (pear trees in late April)	Grants Pass region off I-5

| Willamette Valley (cherry and peach trees at the first of May) | Between Portland and Eugene along rural roads parallel to I-5 |
| Tualatin Valley (filbert and walnut trees) | Hillsboro region along Hwys. 8 and 47 |

SOLITARY TREES

Throughout the hills and valleys of the western part of the state, and in the high desert of eastern Oregon, solitary trees dot the countryside. Picturesque and romantic, they beckon. I once asked a farmer why he left two big oaks in the middle of his otherwise cleared and orderly wheat field. He answered, "In order for those oaks to survive, they had to withstand the wind and rain, the ice and snow, and the heat of summer sun; you need that same determination to survive as a farmer. Having them in my field is a daily reminder." Keep your eye out for the solitary tree.

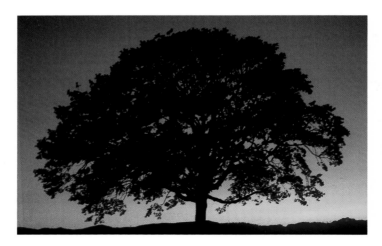

Opportunity Lone oaks dotting the Willamette and Rogue River valleys. Choose a pre-dawn or late-day sky. Late fall and winter are ideal seasons, since the leaves have dropped, exposing a skeletal tree. The wheat, barley, and clover fields lie dormant, making access easy. The east- or west-facing trees, sitting on a knoll or against simple backgrounds, make good subjects.

Point of view and lens choice Kneel to shoot. The closer you are to the tree, the higher it becomes. Choose your lens based on your distance from your subjects.

Exposure If you shoot with a wide-angle or normal lens, use an aperture of f/8. If you shoot with a telephoto, use an aperture of f/16. If you shoot before sunrise or just after sunset, adjust your exposure until a one-stop overexposure is indicated. If your camera has no manual exposure control, set the auto-exposure override to +1 or 2X. Exposures can be too slow to handhold. Use a firm support, such as a bean bag, tripod, or a pair of steady elbows, if you're lying on the ground. If you shoot right at sunrise or just before sunset with a wide-angle or normal lens, set the aperture as described and adjust the shutter speed until a correct exposure is indicated. With a telephoto set the aperture as described, but adjust the exposure according to the light in the sky to the left or right of the sun.

Film choice 100 ISO, color print; 100-50-64 ISO, color slide.

Additional tips

- Keep the horizon straight in the frame.

- Back up and place a small oak on the horizon near the bottom third of your frame, allowing the colorful sky to dominate.

- Don't limit yourself to oaks. A lone maple, pine, or fir are also good subjects.

- Return to your oak at least once each season, as well as on foggy and snowy days.

Good shooting locations

Washington County (oak and maple trees)	Around Hillsboro and Forest Grove
Yamhill County (oak trees)	Around Carlton, Yamhill, McMinnville
Polk County (oak trees)	Around Salem
Benton County (oak trees)	Around Corvallis
Lane County (oak and maple trees)	Around Eugene
Lake County (juniper trees)	Along Hwy. 31
Gilliam County (locust trees)	Around Condon

MOUNTAINS AND DESERTS

Oregon's mountains and deserts are two favorite retreats. The mountains — some young and volcanic, some ancient, sedimentary uplifts — are the backdrops to the state's colorful and surprising sage country and deserts. Hundreds of hiking trails and logging roads lead through forest, both lush and sparse, to the summits. The snow-capped Cascades are, perhaps, the most dramatic mountain range, but be sure to explore the rain-forested Coast Range, the remote Wallowas, and the Siskiyous to the south. Don't forget the basalt cliffs of the Columbia River Gorge.

MOUNTAIN PEAKS

Despite the spectacular scenery of Mount Jefferson, the Three Sisters, the Wallowas, and Crater Lake, Oregon's most popular peak is Mount Hood. More than a half-million people visit Mount Hood National Forest each year, ensuring that the state's tallest peak, at 11,235 feet, is also the most photographed. Typical shots are taken from Lost Lake, Mirror Lake, and Trillium Lake, and countless images are taken from surrounding resort areas and roads. If you'd like to shoot from a more unusual vantage point, consider distant locations such as Hood River, Condon, Wasco, Hillsboro, or even Portland where the mountain's huge size is more evident in relation to the surrounding terrain.

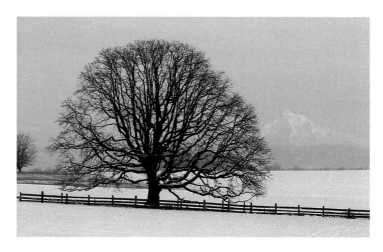

Opportunity The mountain as part of the landscape. Frontlighting brings out detail on both the mountain and landscape year-round.

Point of view and lens choice Use foreground interest to add scale and depth to the scene. Normally a wide-angle or normal lens is the best choice for landscapes. But at great distances from the mountain, a telephoto lens of 135mm or greater is a must. Foreground interest could be a barn, orchards, rolling wheat fields, or highway.

Exposure For a sharp scene use an aperture of f/16 or f/22. For maximum depth-of-field preset the focus according to the depth-of-field scale on the lens. See Technical Information Center. Adjust the shutter speed according to the light reflecting from the scene until a correct exposure is indicated. An aperture priority camera in automatic will set the correct shutter speed for you.

Film choice 100 ISO, color print; 100-64-50 ISO, color slide.

Additional Tips

■ Return to the same location each season to capture the changes.

Opportunity The mountain just before sunrise when you face east or just after sunset when you face west. Backlighting emphasizes the mountain's shape at any time of year.

Point of view and lens choice Choose a spot that allows an unobstructed view. The higher you climb, the fewer the obstructions. Forget about the landscape. The mountain is the object of your shot. A telephoto lens, 200mm or greater, fills the frame with mountain and sky.

Exposure Because the mountain and sky are at the same focused distance, an aperture of f/8 is sufficient. Adjust the shutter speed for correct exposure according to the light on the left or right side of the mountain. If your camera has no manual exposure control, set the auto-exposure override to +1 or 2X.

Film choice 400-200-100 ISO, color print; 400-200-100-64 ISO, color slide.

Additional tips

■ Use a tripod for support. Shutter speeds may be too slow to hand hold.

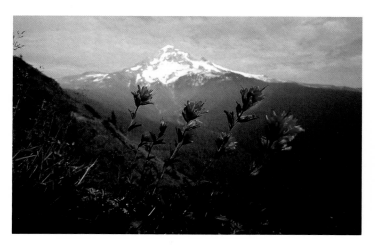

Opportunity Shooting on or very near the mountain. Front-lighting or sidelighting provides good detail.

Point of view and lens choice Emphasize the foreground. Kneel low to meet the flowers at eye-level, or walk up close to the branches of vine maple. Foreground interest creates depth and adds scale to the mountain. Your distance from the mountain determines if you use a wide-angle or normal lens.

Exposure To emphasize the foreground, use an aperture of f/5.6 or f/8. This depicts the mountain as an out-of-focus but definable image. Adjust the shutter speed according to the light reflecting from the scene until a correct exposure is indicated. An aperture priority camera will set the correct shutter speed for you.

Film choice 100 ISO, color print; 100-64-50 ISO, color slide.

Additional tips

- If the sun is directly overhead or due left or right, use a polarizing filter to reduce the harsh glare and to improve color saturation.

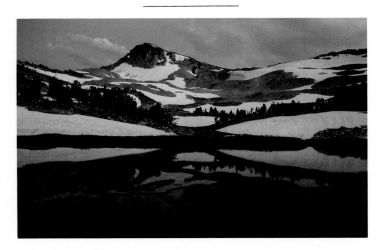

Opportunity Reflections of mountains in alpine lakes. Frontlighting and sidelighting both provide detail on the mountain and surrounding landscape.

Point of view and lens choice Your distance from the edge of the lake and the position from which you shoot determine the amount of reflection in the photo. A 28mm, 24mm, or 20mm wide-angle lens is recommended, but a normal lens works well.

Exposure Use a small lens opening, f/16 or f/22, to sharpen the scene. For maximum depth-of-field, preset the focus according to the depth-of-field scale on the lens. See Technical Information Center. Tilt the camera down so the frame is almost filled with reflection. Adjust the shutter speed for a correct exposure. Then recompose the shot to include the whole scene. If your camera has no manual exposure control, set the auto-exposure override to +1 or 2X.

Film choice 100 ISO, color print; 100-64-50 ISO, color slide.

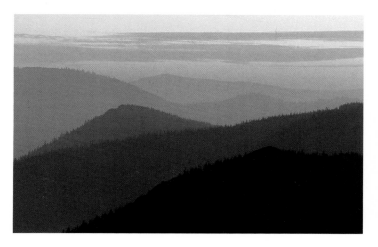

Opportunity At high elevations where mountain peaks and valleys extend for miles before you. To achieve stacking, shoot in early morning or late afternoon when sidelighting occurs.

Point of view and lens choice Choose a position offering the clearest view; then select the most appropriate lens. Use a 200mm or larger lens to capture the design and pattern most effectively.

Exposure Use a lens opening of at least f/11. Tilt the camera down to exclude the sky. Adjust the shutter speed until a correct exposure is indicated. Recompose the shot bringing no more than one-third of the sky into the picture. If your camera has no manual exposure control, set the auto-exposure override to +1 or 2X.

Film choice 100 ISO, color print; 100-64-50 ISO, color slide.

Additional tips

- When the sun is overhead, a polarizing filter reduces the harsh glare and increases the color saturation.

Good shooting locations

Mount Hood (three locations)	Hwy. 206 between Condon and Wasco
	Hood River Valley around Parkdale and Dee
	Washington Park Rose Gardens in Portland's West Hills
Three Sisters and Mount Jefferson	Along US 97 at Bend and from Pilot Butte State Park east of Bend
Wallowas	Along Hwy. 82 at Enterprise

A List of Bryan Peterson's Personally Tested and Favorite Photographic Hiking Trips

These hikes will provide you with spectacular views of mountains, alpine lakes and meadows, and waterfalls. The best time for hiking is mid-July through August.

Mount Hood National Forest, south end Three hikes: Twin Lakes, Battle Axe, and Mount Beachie. Views from Battle Axe and Mount Beachie are extensive. By mid-July the wildflowers are abundant. Take Hwy. 22, just south of the small bridge over Detroit Reservoir. Turn left at Elk Lake Road. Follow signs to Elk Lake campground. Trails begin approximately one-half mile up the road.

Mount Jefferson National Forest (Jefferson Park) The easiest and most popular trail. Head east on Hwy. 22, 10 miles beyond Detroit. Turn left on Whitaker Creek Road #2243. Drive seven and one-half miles to the end of the road. Take the trail for three miles. Late July is best for wildflowers but worst for mosquitoes.

South Cinder Peak Take US 20/126 eight miles south of the Santiam Pass or twelve miles north of Sisters until you reach the sign pointing to Jack Lake (about ¼-mile beyond the 88-mile post). After four and a half miles, the road becomes red cinder. Stay on Road 1211. After one and a half miles, veer right to Road 1210. Stay on Road 1210 for five miles. Curve left to Road 1210B. Drive one and a half miles to the end of the road, a parking lot. Take the trail for good views of Mount Jefferson and several alpine lakes. You also will see a rock wall-rimmed basin as you walk.

Rock Pile Lake, Canyon Creek Meadows, and Booth Lake Follow the directions to South Cinder Peak, except after driving on Road 1211, veer left instead of right. Continue six miles to a parking lot. Set aside several days to capture the beauty of these trails. Spectacular views of lakes and wildflower meadows. Incredible vistas. One of my favorite trips.

Iron Mountain Take US 20 ten miles west of its junction with US 126 or thirty-five miles east of Sweet Home to a sign on the north side of the road marking the beginning of the Iron Mountain Trail. This is a steep hike. But at the top of the mountain wildflowers bloom in abundance, particularly in mid-May. Mosquitoes are not a concern.

Eileen and Husband Lakes Take Oregon 242 for sixteen miles east of its junction with 125, or six and a half miles west of McKenzie Pass. Watch for the Obsidian Trail sign, one-tenth mile south of the 71-mile post. Turn east and proceed three-tenths of a mile to the parking lot. Follow the trail to the junction of other take-off points, a seven and one-tenth mile hike one-way. Along the way, enjoy the lava flows, alpine meadows, obsidian fields, and many streams. Some consider this the most scenic trail in the Three Sisters Wilderness Area. Follow alternate trails at the junction into even more spectacular terrain.

Olallie Mountain Take Oregon 126 for thirteen miles west of its junction with Oregon 242, or 45 miles east of I-5, toward Cougar Reservoir. Turn south. After one-quarter mile, curve right to reservoir. Proceed three miles to north end of reservoir, turn left, and cross dam. Drive two miles to East Fork Road. Keep left on Road 1778. Follow Road 1778 for nine miles to T-junction. Make left turn at sign pointing to Ollalie Trail. Go two miles more to sign marking trail. Take the trail heading south, indicated by arrows, to Ollalie Meadows and Ollalie Mountain Lookout. Trips in late July and early August provide views of wildflower meadows. The view is impressive from the lookout station. The Three Sisters are due east. The best time to shoot the mountain peaks and ranges is in late afternoon: Those to the east are frontlit, and those to the north and south are sidelit.

Base of North Sister From McKenzie Pass, Hwy. 242, go one mile east of Dee Wright Observatory. Head one-quarter mile down Lava Camp Road #1550. This is the head of the trail. During the seven-mile hike, you pass lava fields and the North and South Mather lakes. Enjoy views of Belknap Crater, Mount Washington, Three-Fingered Jack, and Mount Jefferson. Soon the trail drops into a vast meadow of wildflowers. The early morning or late afternoon light creates sidelighting on the mountains and meadows.

Northeast Corner. Eagle Cap Wilderness Area The Wallowa-Whitman National Forest. Take I-84 to La Grande, then Hwy. 82 to Enterprise, then on to Wallowa Lake. More than 50 lakes and numerous alpine meadows lie among the snow-covered peaks. Of special interest are the hikes on the south side of the wilderness and the valleys of the Minam and Imnaha river. This area, though spectacular, does not attract the summer crowds that pack Glacier and Ice lakes.

Additional tips

- During late July and August, thunder and lightning storms occur without warning, particularly in the Mount Jefferson and Three Sisters Wilderness areas. Do not stand on peaks, ridges, or other high points. Avoid taking refuge beneath a lone tree or rock.

- Because of the sudden changes in weather, take a light load of extra clothing: knit cap, gloves, sweater, and a lightweight, waterproof jacket.

- Do not discount the possibility of an accident. It is easy to slip on even the smoothest trail. Carry a flashlight, first aid kit, and a whistle.

- For extra safety, take a granola bar or nut mix. Few delays are caused by accidents or storms. Most are because of lingering in the woods and meadows.

- Don't scrimp on film. Carry at least 20 percent more film than you think you can shoot. Film is cheap compared to the trauma of running out of film halfway into the hike.

In addition to the hiking trails I've mentioned, you'll find hundreds more in the National Forests and other government lands. Listed below are headquarters from which you can obtain maps and information about the trails and local roads.

Mount Hood National Forest
19559 S.E. Division St.
Gresham, Oregon 97030
(503) 667-0511

Willamette National Forest
210 E. 11th Avenue
Eugene, Oregon 97401
(503) 687-6521

Deschutes National Forest
211 N.E. Revere
Bend, Oregon 97701
(503) 382-6922

Ochoco National Forest
P.O. Box 490
Prineville, Oregon 97845
(503) 447-6247

Malheur National Forest
139 N.E. Dayton St.
John Day, Oregon 97845
(503) 575-1731

Umatilla National Forest
2527 S.W. Haily Avenue
Pendleton, Oregon 97801
(503) 276-3811

Wallowa-Whitman National Forest
P.O. Box 907
Baker, Oregon 97814
(503) 523-6391

Umpqua National Forest
P.O. Box 1008
Roseburg, Oregon 97470
(503) 672-6601

Winema National Forest
7th and Walnut
P.O. Box 1390
Klamath Falls, Oregon 97601
(503) 882-7761

Crater Lake National Park
P.O. Box 7
Crater Lake, Oregon 97604
(503) 594-2211

John Day Fossil Beds
U.S. National Park Service
John Day, Oregon 97845
(503) 575-0721

Pueblo, Steens Mountains, and Alvord Desert
U.S.B.L.M.
74 S. Alvord Street
Burns, Oregon 97720
(503) 573-2071

FORESTS

From the mosses and ferns of coastal rain forests to the soft needle floors of the pine country east of the Cascades, Oregon's forests offer a vast range of trees, plants, birds, game—and moods. Knowing what you want to capture and planning ahead are the keys to making your forest foray a photographic success. Be ready to find beauty where it's least expected: in a delicately-textured, nearly-hidden fall mushroom; in new growth springing from an ancient tree stump; in the remnants of a log bridge, abandoned and forgotten decades ago. Perhaps most surprising of all—Hoyt Arboretum and Forest Park constitute a substantial forest, all inside the city limits of Portland! While good forest photography may take a little extra effort, in Oregon it's well worth it.

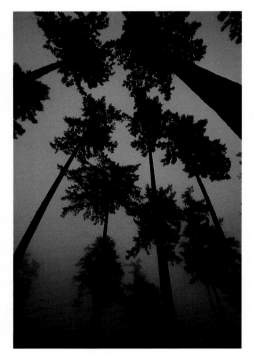

Opportunity Stands of fir, alder, and aspen.

Point of view and lens choice Stand near the base of the trees and look up with a 28mm, 24mm, or 20mm wide-angle lens. This forces the trees toward the sky, emphasizing their size, strength, and power.

Exposure Use a small lens opening, f/16 or f/22, to sharpen the whole scene. For maximum depth-of-field, preset the focus according to the depth-of-field scale on the lens. See Technical Information Center. Then adjust the shutter speed for the correct exposure according to the weather and the direction of the light. When shooting in fog or into the sun, adjust the shutter speed to one stop over the indicated reading. If your camera has no manual exposure control, set the auto-exposure override to +1 or 2X.

Opportunity Early fall in the mountains, vine maple exploding in vivid reds and oranges. Choose an overcast or rainy day.

Point of view and lens choice Move in close with a 28mm, 24mm, or 20mm wide-angle lens. This fills the foreground with bright-colored leaves, in addition to bringing in the surrounding forest floor.

Exposure Use a small lens opening, f/16 or f/22, to sharpen the whole scene. For maximum depth-of-field, preset the focus according to the depth-of-field scale on the lens. See Technical Information Center. Adjust the shutter speed according to the light reflecting from the scene. An aperture priority camera in automatic will set the correct shutter speed for you.

Film choice 100 ISO, color print; 100-64-50 ISO, color slide.

Additional tips

- A polarizing filter reduces or eliminates the gray glare from the surface of the leaves.

- With your telephoto lens, move within several inches of foreground branches and focus through them to other branches, six or seven feet away. To keep the framework of leaves out-of-focus, set your aperture around f/5.6.

- With close-up equipment, concentrate on the pattern of a single leaf on the ground or on a branch. Since depth-of-field is limited, frame the leaf parallel to the film plane.

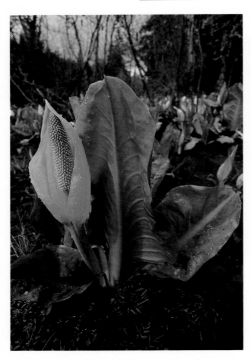

Opportunity The forest floor in spring, alive with new growth — ferns, trillium, skunk cabbage, Solomon's seal. Overcast days provide equal distribution of light.

Point of view and lens choice Use a wide-angle lens for close-ups. Shoot full-frame and eye-level.

Exposure Emphasize the foreground by keeping the aperture nearly wide open; try f/5.6. Adjust the shutter speed according to the light reflecting from the scene until a correct exposure is indicated. An aperture priority camera in automatic will set the correct shutter speed for you.

Film choice 100 ISO color print; 100-64-50 ISO, color slide.

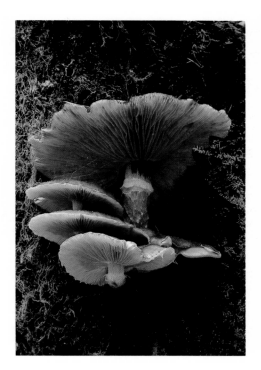

Opportunity During fall when the forest floor is alive with mushrooms. Choose an overcast or rainy day.

Point of view and lens choice Shoot the subject at its level to bring the viewer into the photo. Close-up equipment is ideal for small subjects. When possible, keep the subject parallel to the film plane. Several alternates are: a zoom lens set at close focus; close-up filters on a normal lens; extension tubes on a normal or telephoto lens; a macro-converter on a normal lens; or an actual macro lens.

Exposure Because depth-of-field is limited when shooting close-ups, use an aperture of at least f/8. Adjust shutter speed according to the light reflecting from the scene until a correct exposure is indicated. An aperture priority camera in automatic will set the correct shutter speed for you.

Film choice 100 ISO, color print; 100-64-50 ISO, color slide.

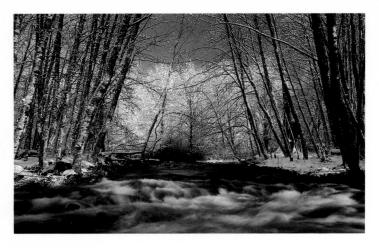

Opportunity Winter snow scenes near rivers, lakes, and streams. Sunny days make crisp and cold photographs. Use frontlight or sidelight to show detail.

Point of view and lens choice The wide-angle lens is usually used for landscapes. Foreground interest, for instance, the edge of the stream, creates depth. Since the trees are a strong element in the scene, give them room in the frame to grow — at least two-thirds.

Exposure Use a small lens opening, f/16 or f/22, to sharpen the whole scene. For maximum depth-of-field, pre-set the focus according to the depth-of-field scale on the lens. See Technical Information Center. Adjust the shutter speed until a one-stop over exposure is indicated from the scene, or use the gray card in the back of this book. If your camera has no manual exposure control, set the auto-exposure override to +1 or 2X.

Film choice 100 ISO, color print; 100-64-50 ISO, color slide.

Additional tips

■ If your subjects are sidelit, use a polarizing filter to deepen the blue sky.

Good shooting locations

Cascade Head	Off US 101 four to five miles north of Lincoln City on marked trail
Bell Mountain region	Off Hwy. 47 north of McMinnville
Smith River	Off I-5 at Cottage Grove, west on rural road through Lorane to Gardiner on the coast

Nehalem River	Off US 26 at Elsie, south then west to town of Nehalem
Silver Falls State Park	On Hwy. 214 southeast of Salem
Columbia Gorge	Off I-84 along Columbia Gorge Scenic Hwy.
McKenzie River	Off I-5 at Eugene beginning at Leaburg on Hwy. 126 to US 20, then west to Cascadia
Diamond Peak Wilderness and North Umpqua River	Off I-5 to Hwy. 58 beginning at McCredie Springs to Hwy. 97, south to Diamond Lake Junction, then west on Hwy. 138 past Diamond Lake to Steamboat Ranger Station

WATERFALLS

Cascading down rock steps or plunging over vertical cliffs, Oregon's waterfalls are impressive, inspiring, and a challenge to photographers. Often set in difficult locations recessed by the cutting action of the falling water itself, the waterfall can be difficult to frame and the exposure hard to control. But the results can be spectacular. Whether you "freeze" the falling water or reveal the motion with longer exposures, waterfalls present many moods depending on season, water flow, wind conditions, and weather.

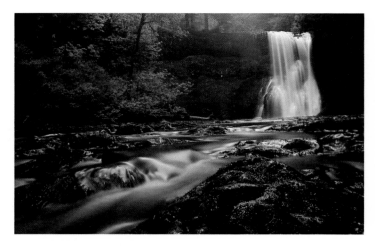

Opportunity Waterfalls in late May through October, when surroundings offer color and foliage. An overcast or rainy day is ideal because light is distributed equally.

Point of view and lens choice A wide-angle or normal lens allows you to include the surrounding foliage and trees. Kneel to take in the edge of the stream or a clump of ferns. Move in close or near to the level of the subject to include a big leaf maple branch or dogwood blossoms. Foreground interest creates depth.

Exposure For a sharp scene use an aperture of f/16. For maximum depth-of-field, preset the focus to the depth-of-field scale on the lens. See Technical Information Center. Adjust the shutter until a correct exposure is indicated. Note: To achieve a cotton-candy effect for the waterfall, use a 1/4-second or longer exposure. To maintain correct exposure at this speed, you may need to use a neutral density filter. Because 1/4-second or longer exposures are too slow to hand hold, use a firm support, such as a rock, stump, or tripod.

Film Choice 100 ISO, color print; 100-64-50-25, color slide.

Additional tips

- Use a polarizing filter to remove the gray glare from the surface of the water and wet foliage.

- If the composition includes more than one-half of the waterfall, set the exposure to one stop over, or use the gray card in the back of this book. If your camera has no manual exposure control, set the auto-exposure override to +1 or 2X.

- If you are shooting in the waterfall spray, or if it is raining, be sure your lens is dry.

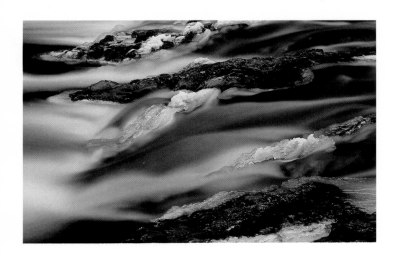

Opportunity Small waterfalls on an overcast or rainy day when light is distributed equally.

Point of view and lens choice The telephoto lens most effectively isolates a small part of the scene. Shoot the waterfall full-frame.

Exposure The angle of the subject to the film plane determines the proper f/stop. For sharpness from top to bottom, use a small lens opening, f/16 or f/22. Adjust the shutter speed according to the light reflecting from the scene until a correct exposure is indicated. An aperture priority camera in automatic will set the correct shutter speed for you. To achieve the cotton-candy effect of the rushing water, the shutter speed must be 1/4-second or longer. To maintain a correct exposure at this speed, you may need to use a neutral density filter.

Film choice 100 ISO, color print; 100-64-50 ISO, color slide.

Good shooting locations

Multnomah Falls (620 total feet)	Columbia Gorge at Exit 31 off I-84, or via Columbia Gorge Scenic Hwy.
Wahkeena Falls (242 feet)	On Columbia Gorge Scenic Hwy., a half mile west of Multnomah Falls
Latourell Falls (249 feet)	On Columbia Gorge Scenic Hwy. at Guy W. Talbot State Park
Elowah Falls (289 feet)	Via trail from John B. Yeon State Park on Columbia Gorge Scenic Hwy.
Youngs River Falls (50 feet)	Southeast of Astoria on Hwy. 202, turn on road marked to falls.
Fish Hawk Falls (50 feet)	Four and a half miles from Jewell on Hwy. 202
Munson Creek Falls (266 feet)	Off US 101 at Beaver, turn at sign to falls
Alsea Falls (40 feet)	Off Hwy. 34 at Alsea, south for one mile, then left for eight and a half miles to falls

Silver Falls (100 feet)	On US 101 turn at Coos Bay to town of Eastside. Proceed 24 miles to falls at Golden and Silver Falls State Park.
Elk Creek Falls (75 feet)	Off Hwy. 42, three miles up South Fork Coquille River Road to Powers Ranger Station, then six miles to Elk Creek picnic grounds
Ramona Falls (45 feet)	Off US 26 on Lolo Pass Road, turn right on Muddy Fork Road, then take trail to falls.
Switchback Falls (150 feet)	On Hwy. 35 one and a half miles past Mount Hood Meadows Road
Tamanawas Falls (125 feet)	On Hwy. 35 fourteen miles south of the town of Mount Hood. Take trail to falls.
Garch Falls (75 feet)	Off Hwy. 22 at Marion Forks, turn on Marion Creek Road #2255, go three and a half miles. Turn right on #2255/850 to falls.
South Falls (177 feet)	At Silver Falls State Park on Hwy. 214. Note: Nine other falls in park.
Sahalie Falls (140 feet)	On Hwy 126, five miles south of US 20
Koosah Falls (100 feet)	Almost one half mile on Hwy. 126 from Sahalie Falls
Royal Terrane Falls (119 feet)	At McDowell Falls Area, off US 20 at Fairview, turn on McDowell Creek Road to park.
Rainbow Falls (175 feet)	Off US 126 turn on Foley Ridge Road, then right on #3543 to falls.
Proxy Falls (200 feet)	Off US 126 turn on Hwy. 242 to trail turnout, trail to falls.
Salt Creek Falls (286 feet)	Twenty-one miles east of Oakridge on Hwy. 58
Grotto Falls (100 feet)	Off Hwy. 138 turn on Little River Road, sixteen miles to road #2703, then left on #2703/150. Take trail to falls.

Lemolo Falls (75 feet)	Off Hwy. 138, turn on Thorn Prairie Road #3401, then right at Lemolo Falls Road. Take trail to falls.
Wallowa Falls (40 feet)	Hwy. 82 to Wallowa State Park, take long trail to falls.
Mill Creek Falls (173 feet)	Off US 62 onto Mill Creek Road to marked turnout
Dillon Falls (50 feet)	On Century Drive from Bend for six miles, then left on road #1808
Paulina Creek Falls (100 feet)	Off US 97 toward Paulina Lake, six miles north of LaPine
Deep Creek Falls (40 feet)	Adjacent to Hwy. 140, three miles west of Adel

DESERTS

Although the word desert contradicts Oregon's well-promoted image of tall evergreen forests and frequent rains, about a quarter of the state is a high desert. Occupying the southeast portion of the state, this desert is part of the great basin linking Oregon to parts of Nevada, Idaho, and Utah. This high plateau is marked by spectacular rock cliffs or escarpments. For the photographer, it is full of strong images if one looks closely, and discovers its power and beauty.

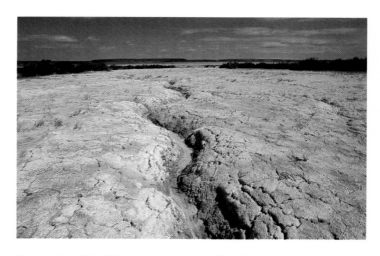

Opportunity The desert floor. Sidelighting emphasizes texture and depth.

Point of view and lens choice To make the whole scene sharp, use an aperture of at least f/16. For maximum depth-of-field, preset the focus according to the depth-of-field scale on the lens. See Technical Information Center. Adjust your shutter speed according to the light reflecting from the scene until a one stop over exposure is indicated. If your camera has no manual override, set the auto-override to +1 or 2X. Note: For manual exposures you can also use the gray card in the back of the book.

Film choice 100 ISO, color print; 100-64-50 ISO, color slide.

Additional tips

- When shooting at mid-day, use a polarizing filter to reduce the glare from the sand and to increase color saturation in the sky.

- Do not set your camera bag on the sand if the day is windy. Keep it around your shoulder or place it on stump or log. To avoid getting sand inside the camera body, carefully change lenses or film with your back to the wind.

- If you leave film in your parked car, do not store it on the seat or in the glove box. Temperature inside the car can climb toward 200° F. Store it in an insulated bag or cooler.

Good shooting locations

Lava Butte Geological Area	Ten miles south of Bend on US 97
Lava Cast Forest Geological Area	Thirteen miles south of Bend on US 97
Jordan Valley (Basque sheep-herders)	On US 95 near the Idaho border
Abert Rim (High fault scarp)	North of Lakeview along US 395
Owyhee Lake	Forty miles south of Ontario off US 201
Alvord Desert	South of Hwy. 78 on a rural gravel road
Fort Rock State Park	East of Hwy. 31 on a rural gravel road
Succor Creek Canyon (canyon of pinnacles, towers, cones, spires)	Off US 95, gravel road to Succor Creek State Park

Leslie Gulch	Nine miles south of Succor Creek
(red cliffs and pin-	State Park, take junction to
nacles of great height)	Leslie Gulch.

Also see wildlife and wildflower locations for listings of desert refuges and Steens Mountain.

WILDFLOWERS AND WILDLIFE

Throughout the state two favorite subjects, wildflowers and wildlife, can be found in their respective locations and seasons. Each subject requires different techniques to obtain the best images, but the results are well worth the extra effort. In both cases, a little knowledge about your subject will go a long way, and reduce the chances of coming back empty handed.

Wildflowers

"What a desolate place our world would be without a flower. It would be a face without a smile, a feast without a welcome." Fortunately, the photographer in Oregon need never worry about the state becoming a desolate place. Our seasonal climate and varied terrain produce wildflowers in abundance throughout the spring and summer. Indian paintbrush, camas, columbine, bear grass, purple iris, buttercup, shooting star, balsam root, lupine, and fireweed are a few to look for. You'll discover hundreds of varieties grow here—and beg to be captured on film.

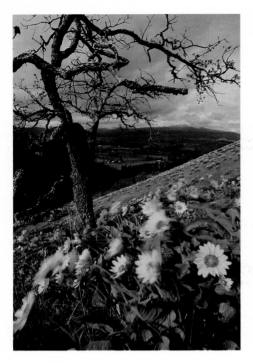

Opportunity Landscapes with wildflowers, shot on bright overcast or cloudy days.

Point of view and lens choice Meeting the flowers at their level brings the viewer into the photograph. A normal lens can work, but a 28mm, 24mm, or 20mm wide-angle lens is preferable because it allows you to include more of the scene.

Exposure Use a small lens opening, f/16 or f/22, to sharpen the whole scene. For maximum depth-of-field, preset the focus according to the depth-of-field scale on the lens. See Technical Information Center. Adjust shutter speed according to the light reflecting from the scene until a correct exposure is indicated. Note: If the landscape is sidelit and you want detail in the shadows, set the exposure to one stop over that which is indicated. If you are shooting on an overcast day and the sky is more than one-third of your composition, tilt the camera down to eliminate the sky; then set the exposure. If your camera has no manual exposure control, set the auto-exposure override to +1 or 2X in both of these cases.

Film Choice 100 ISO, color print; 100-64-50 ISO, color slide.

Additional tips
- For vivid, sidelit landscapes, use a polarizing filter.

60

- Avoid early morning or late afternoon frontlit landscapes when you use a wide-angle lens. Your shadow falls on the immediate foreground, distracting attention from the main subject.

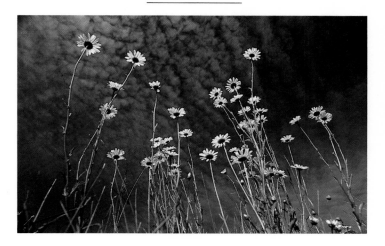

Opportunity From summer through fall, roadsides and meadows, home of tall flowers, such as daisies, Queen Anne's Lace, foxglove, fireweed. For maximum impact, use front or sidelighting.

Point of view and lens choice For a dramatic shot, lie on your back by the base of the flowers and shoot up with a wide-angle lens.

Exposure Use an aperture of f/16 to create sharp detail over the entire group of flowers. Adjust your shutter speed according to the light reflecting from the scene until a correct exposure is indicated. An aperture priority camera in automatic will set the correct shutter speed for you. If you are shooting against a cloudy sky, the exposure should be set one stop over the indicated reading. If your camera has no manual exposure control, then set the auto-exposure override to +1 or 2X.

Film choice 100 ISO, color print; 100-64-50 ISO, color slide.

Additional tips

- If the flowers are sidelit, a polarizing filter makes the sky a deeper blue.

- Shoot both vertical and horizonal frames.

- Don't allow telephone lines in your compositions.

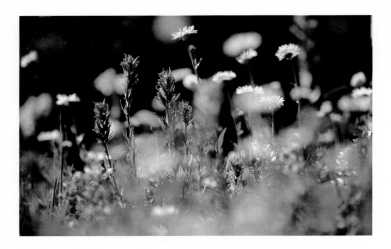

Opportunity Using selective focus on flowers growing close together in alpine meadows and roadside ditches.

Point of view and lens choice Meet the flowers at their level and move in closely enough to have several blooms within inches of your telephoto-zoom or telephoto lens. A 135mm or greater focal length proves most effective. As you focus through the foreground flowers, inches away from your lens, they become out-of-focus colors, framing the flowers upon which you focus at a distance of four to eight feet.

Exposure Since this effect depends on a shallow depth-of-field, use an aperture of f/4 of f/5.6. Adjust the shutter speed according to the light reflecting from the scene until a correct exposure is indicated. An aperture priority camera in automatic will do this for you.

Film choice 100 ISO, color print; 100-64-50 ISO, color slide.

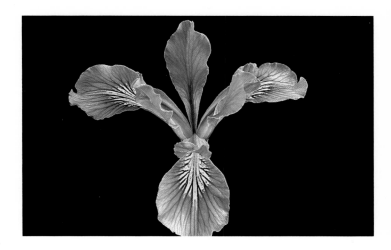

Opportunity Wildflowers against dark backgrounds; single flowers sidelit or backlit with a background in open shade.

Point of view and lens choice Meet the flower at its level with the zoom lens set at close focus. Several alternatives are: a zoom lens set at close focus; close-up filters on a normal lens; extension tubes on a normal or telephoto lens; a macro-converter on a normal lens; or an actual macro lens.

Exposure The flower's shape and its angle to the camera determine the proper f/stop. If the flower has a globular shaded or angled head, use f/16. If the flower head is flat and parallel to the film plane, use f/8. Take two exposures of the flower. Adjust the shutter speed for a correct exposure, and shoot. Then take one more at one stop under exposed. If your camera has no manual exposure control, set the auto-exposure override to −1 or ½X for the second shot.

Film choice 100 ISO, color print; 100-64-50 ISO, color slide.

Additional tips

- If there is no shadow in the background, place a black matte board 10 to 12 inches behind the flower. The sunlight should not hit the board, and the black background should fill the entire frame. Expose in the same manner explained in the previous paragraph.

- Shoot in the first hours of morning light when little wind is present.

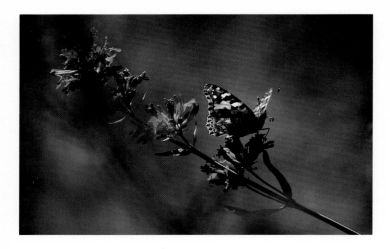

Opportunity Wildflower meadows, the home of numerous insects — dragonflies, grasshoppers, and butterflies. Shoot in early morning when insects are least active.

Point of view and lens choice Meet the subject at its level to bring the viewer into the photo. A telephoto zoom set to close-focus or a 200mm telephoto with an extension tube allows you to get a close-up without actually being close.

Exposure A shallow depth-of-field is important so the insect won't be lost in a busy background. Use an aperture of f/4 or f/5.6. Adjust the shutter according to the light reflecting from the scene until a correct exposure is indicated. An aperture priority camera in automatic will do this for you.

Film choice 100 ISO, color print; 100-64-50 ISO, color slide.

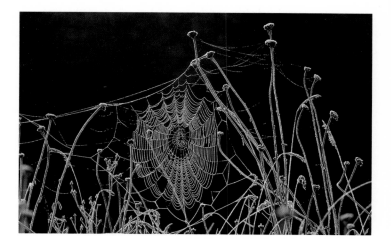

Opportunity The summer's wildflowers now supporting the autumn spider web.

Point of view and lens choice Arrive just before sunrise and face the meadow to the east. This places you in a good position to see the soon-to-be-backlit spider webs. Meet the webs at their level and look for shadowy backgrounds against which to shoot. In addition to the telephoto and telephoto zoom lens, you may use close-up equipment.

Exposure For uniform sharpness use an aperture of f/8 when the web is parallel to the film plane. Use an aperture of at least f/16 when the web is at an angle. Adjust the shutter speed until a correct exposure is indicated. When the web is backlit, take an additional exposure at one stop under-exposed.

Film choice 100 ISO, color print; 100-64-50 ISO, color slide.

Additional tips.

- Whether the webs are covered with dew or frost, they dry up soon after the sun hits them. Finding a web quickly and using it creatively is essential.

- If the dew has disappeared, use a spray bottle filled with water and mist the web.

- Shoot in the early morning hours when little wind is present.

Good shooting locations

Wildflowers can be identified by their environments, including such factors as sunlight, elevation, moisture, and type of drainage. From dry desert up to alpine meadows and down to damp coast, Oregon is blessed with a variety of habitats to explore for wildflowers.

Steens Mountain (April-May below 5,000 feet, July-August above 5,000 feet)	South of Hwy. 78, west of Burns Junction
Alvord Desert (April-May)	South of Steens Mountain
Cascades (August)	See forest floor section
Valleys (April-August)	Tualatin, Willamette, Rogue, Hood River
Coast (April-May)	Saddle Mountain off US 26, twelve miles inland from Cannon Beach
Big Summit Prairie (May)	Thirty-three miles east of Prineville, turn off US 26 on to paved road to Ochoco Ranger Station

WILDLIFE

Oregon's assortment of terrain, combined with vast, sparsely populated areas, offers the photographer a year-round setting for wildlife photography. Getting these shots can become a test of patience; professionals often wait in the same spot for days to get even one good shot. To improve your odds for success, explore designated game areas and refuges. Some offer maps and guides as well as convenient blinds for the photographer. For accurate seasonal and first-hand advice, talk to a refuge manager or game warden in the area. Whether you prefer the patience-and-crouching method or the quick-draw approach, stalking Oregon's wildlife with your camera is rewarding and memorable.

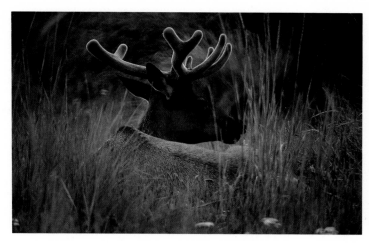

Opportunity Mammals during the early morning or late afternoon. Frontlight reveals the details of the mammals. The backlight of sunrise or sunset, however, creates pleasing silhouettes.

Point of view and lens choice Meet the subject at its level and choose the clearest view. Use a telephoto lens — the 400mm to 600mm range — since you must shoot the subject full-frame. If you have a telephoto-zoom or fixed 200mm lens use a doubler.

Exposure If you are not using a tripod or monopod, use a fast shutter speed to correct for the loss of sharpness resulting from hand-holding the camera. The slowest shutter speed is 1/250-second for a hand-held camera. Using wide-open or almost wide-open aperture not only keeps your shutter speed up, but also isolates the subject because of the shallow depth-of-field.

Film choice 400-200-100 ISO, color print; 400-200-100-64 ISO, color slide.

Additional tips

- When shooting from a car, turn off the engine to eliminate vibrations.

- Be ready to shoot as you walk or drive. Advance the film and set an exposure for frontlit subjects.

- If the rising or setting sun backlights the subject, take your exposure according to the light to the left or right of the sun. If your camera has no manual exposure control, set the auto-exposure override to +1 or 2X.

Opportunity Wildlife remnants, such as feathers, antlers, skulls, and eggs. Shoot on an overcast day when light is distributed equally. On sunny days emphasize detail by frontlighting.

Point of view and lens choice Shoot the subject full-frame. This may require that you use a close-up or telephoto lens and that you walk close to the subject.

Exposure If your subject is parallel to the film plane, an aperture of f/8 is adequate. If your subject is at an angle, you may need an aperture of f/16. Adjust the shutter speed according to the light reflecting from the scene until a correct exposure is indicated. An aperture priority camera in automatic will set the correct shutter speed for you.

Film choice 100 ISO, color print; 100-64-50 ISO, color slide.

Good shooting locations

Lewis & Clark National Wildlife Refuge (whitetail deer) — Nine miles west of Westport off US 30 to Brownsmead and Aldrich Point

Jewell Meadows Wildlife Area (elk) — One mile west of Jewell on Hwy. 202 off US 26

Sauvie Island Wildlife Area (waterfowl and swans) — Off US 30 just beyond Portland's city limits

William L. Finley National Wildlife Refuge (Canada geese) — Ten miles south of Corvallis on Hwy. 99W

Kenneth E. Denman Wildlife Area (birds)	Six miles from I-5 at Medford on Hwy. 62 to Agate Road junction
Estuaries (egrets and pelicans)	Around Coos Bay; Yaquina Bay, Newport; Alsea Bay, Waldport; and Tillamook Bay
Caves (sea lions)	Sea Lion Caves (admission fee) on US 101, ten miles north of Florence
White River Wildlife Area (black tail deer)	At Wamic off US 197
Crane Prairie Reservoir Osprey Area (osprey)	Forty-eight miles west of Bend on Century Hwy.
Klamath Forest National Wildlife Refuge (waterfowl)	Forty-five miles north of Klamath Falls off US 97
Upper Klamath National Wildlife Refuge (waterfowl)	On the Klamath Falls-Klamath Agency Road off US 97
Umatilla National Wildlife Refuge (waterfowl)	From Umatilla west along the Columbia River adjacent to US 730 and I-84
Wenaha Wildlife Area (elk and deer)	At Troy on Asotin County Road off (Oregon) Hwy. 3/(Washington) Hwy. 129
Ladd Marsh Wildlife Area (nesting birds)	Along I-84 just south of La Grande
Summer Lake Wildlife Area (birds)	On Hwy. 31 between Lakeview and Bend
Malheur National Wildlife Refuge (nesting birds and waterfowl)	Thirty miles south of Burns along Hwy. 205 for about forty miles
Hart Mountain Antelope Range	Off US 140 on dirt road past town of Plush

PARADES AND FAIRS

Colorful parades and fabulous fairs—from spring to autumn, at least one is probably taking place on any given Oregon weekend. They're an open door for character studies, for candids, and fantasy shots of multi-colored midways-by-night. Whether you tend to focus on the cotton candy vendor or the excited child about to experience the thrill of a first carnival ride, your collection of candids is bound to multiply at a carnival. Beginning photographers often fear being chased away. The more candid you are, however, the less trouble you're likely to encounter. The sneaky, surreptitious photographer tends to arouse fear or suspicion, so approach with friendly nonchalance and confidence. Put your subject at ease by being at ease yourself. Don't be surprised if the proud owner of a 4-H steer asks you to shoot a picture for him. Or her.

FAIRS

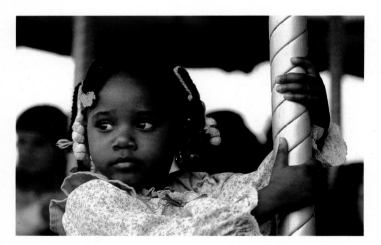

Opportunity The children's rides section, a good place to overcome fears of photographing people. Shoot with side-light, in open shade, or on an overcast day.

Point of view and lens choice When possible meet the subject at his/her eye-level to bridge the generation gap. Use a 135mm telephoto lens. It allows you to fill the frame without interrupting the candid activity. Avoid cluttered backgrounds.

Exposure When isolating subjects, use an aperture of f/5.6 or less. Adjust shutter speed according to the light reflecting from the scene until a correct exposure is indicated. If the background is brighter than the subject, shoot at one stop over the indicated reading. If your camera has no manual exposure control, set the auto-exposure override to +1 or 2X.

Film choice 400-200-100 ISO, color print; 400-200-100-64 ISO, color slide.

Opportunity Following sunset, when midways become fluid, producing electric rainbows, flying fantasias of fireworks. The multi-colored neon-lighted rides invite motion-filled and sometimes abstract treatments.

Point of view and lens choice Shoot the rides full-frame, in motion, by standing near them or by using a telephoto lens from a distance.

Exposure Set your shutter speed to one-second and adjust the aperture until a correct exposure is indicated. A firm support or tripod makes the scene sharp. During the one-second exposure, also try swirling the camera in the same direction of the ride as you hand-hold the camera to make an abstract shot.

Film choice 100 ISO, color print; 100-64-50 ISO, color slide.

PARADES

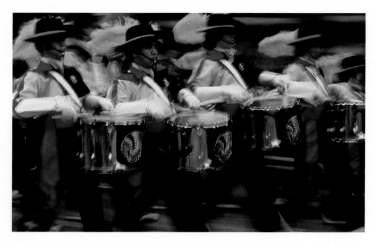

Opportunity Panning the color and excitement of a parade. Overcast days are best, but use front lighting on sunny days if necessary.

Point of view and lens choice Use a telephoto lens to frame a group of percussionists; the more brightly clothed, the better.

Exposure Set your shutter speed to 1/30-second. Adjust the aperture until a correct exposure is indicated. As you focus on the band, move the camera with the musicians and trip the shutter. This technique is called panning. The streaked effect heightens the excitement.

Film choice 100 ISO, color print; 100-64-50 ISO, color slides.

Other considerations

- Arrive early at the parade for a front-row seat. Choose a spot at the beginning of the parade route where your subjects are fresh.

- If you shoot from a stairway or from a window above the parade, use a telephoto lens to record the colorful patterns of the marching bands.

- When the parade column halts for a rest, move into the street and shoot head on. Use a low point of view; a wide-angle or normal lens emphasizes the power of the subjects.

- With a 200mm lens focus on the expressions of the crowds across the street.

- Pay attention to the wide-eyed expressions of children as the parade passes by.

- If you are shooting *slide* film and the subjects are in the open shade, use an 81-A warming filter to reduce the bluish cast on your film.

Good shooting locations

Oregon State Fair	State fairgrounds in Salem, in late August to Labor Day
Portland Rose Festival	Three parades, midway, many ceremonies and events in Portland in early June
Pendleton Roundup	Parade and rodeo in mid-September
Albany Timber Carnival	In Albany on Fourth of July weekend
Pear Blossom Festival	In Medford in early April
Blossom Festival	In Hood River on last Sunday in April
Oktoberfest	Mt. Angel (and other locations) in mid-September
Azalea Festival	In Brookings the last weekend of May
County Fairs	Check with local Chambers of Commerce for dates and locations.

HISTORIC PLACES

Ancient tribes, Spanish explorers, missionaries, miners, pioneers, trappers, cattlemen, sheepherders, sodbusters. Those groups and many more left us unique reminders of the vital roles they played in Oregon's past. Located at the fabled end of the Lewis and Clark route and, later, the Oregon Trail, the state offers a number of cherished locations and landmarks. Vintage homes, forts, churches, entire ghost towns, and even wagon ruts still exist and await the photographer whose heart lies in the long-ago.

GHOST TOWNS

Empty school houses, saloons with dusty bars, dark mine entrances, and dry sluice boxes along with broken wagon wheels and hitching posts that wait for the next horse to be tied up—these images can still be found in parts of Oregon although more vanish each year. Oregon's ghost towns make dramatic photographs. Beyond the overview shot, look for ways to draw details of these old towns into your pictures.

Opportunity Reflections of the past in the windows of a ghost town.

Point of view and lens choice Unless you want to be in the picture yourself, shoot the window at an angle. Use a wide-angle or normal lens.

Exposure Use a small lens opening, f/16 or f/22, to sharpen the whole scene. For maximum depth-of-field, preset the focus according to the depth-of-field scale on the lens. See Technical Information Center. Adjust the shutter speed according to the light reflecting from the scene until a correct exposure is indicated. An aperture priority camera in automatic will set the correct shutter speed for you. Note: If the foreground window is in sunlight and the reflection is in

shadow, increase the exposure by one stop. If your camera has no manual exposure control, set the auto-exposure override to +1 or 2X.

Film choice 100 ISO, color print; 100-64-50 ISO, color slide.

Good shooting locations

Shaniko (hotel, jail, blacksmith shop, and other buildings)	Fifty-five miles south of Wasco on US 97
Hardman (six or seven old weathered buildings)	Off Hwy. 206/207 at Ruggs, left onto Hwy. 207 to Hardman
Golden (church, store, and unfinished building)	Four miles east of Wolf Creek on Coyote Creek Road
Blitzen (old buildings)	South of Frenchglen for 13 miles on Hwy. 205, then right at marked sign to Blitzen

CHURCHES AND CEMETERIES

Often the first large structures in frontier towns, and often the most visually interesting, old churches provide great shooting opportunities throughout Oregon. They are easy to locate and accessible. The older churches often have adjacent cemeteries, another great source of bittersweet historic imagery.

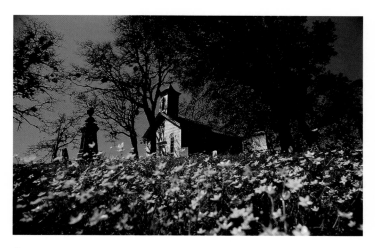

Opportunity Pioneer churches and cemeteries. Take advantage of frontlighting on a sunny day. Many wildflowers bloom in May, but by Memorial Day lawnmowers have moved in.

Point of view and lens choice When composing photographs of churches and surrounding landscapes, your position determines the lens. From a distance use the telephoto lens. At a close range use the wide-angle. Kneeling and shooting with a wide-angle lens creates foreground interest, depth, and a feeling of viewer participation.

Exposure Use a small lens opening, f/16, or f/22, to sharpen the scene. For maximum depth-of-field, preset the focus to the depth-of-field scale on the lens. See Technical Information Center. Adjust the shutter speed according to the light reflecting from the scene for the correct exposure. An aperture priority camera in automatic will set the correct shutter speed for you.

Film choice 100 ISO, color print; 100-64-50 ISO, color slide.

Additional tips

- If you are shooting at mid-day or in sidelight, a polarizing filter reduces the glare, in addition to deepening the color of the blue sky.

Good shooting locations

Spring Valley Community Church	Off Hwy. 221 north of Salem, or south of Dayton, turn at Lincoln Country Store. Go about two and a half miles.
Old Scotch Church	Off Hwy. 26 at North Plains exit, go south on Glencoe Road for two miles, then left on Zion-Church Road for three-quarters mile to church.
McFarland Community Church	On US 99W south of Corvallis
Old Locust Grove Church	On Hwy. 206 five miles west of Wasco. Permission needed to enter private property. Inquire locally.
Lone Rock Church	Off Hwy. 206 at Condon, gravel road to Lone Rock is twenty-five miles long.

Good shooting locations: additional historic places

Astoria Column (1926)	Located in Astoria. Routes well-marked to hilltop.
Fort Clatsop National Memorial (reconstruction 1805)	Six miles southwest of Astoria off US 101
Moyer House (1881)	106 Main Street, Brownsville, Linn County
Benton County Historical Museum (1865)	1101 Main Street, Corvallis
Minthorn House (1881)	South River and E Streets, Newberg
John McLoughlin House National Historic Site (1846)	Seventh and Center Streets, Oregon City
Bybee-Howell House (1856)	North of Portland on US 30, then over Sauvie Island Bridge to house
Pittock Mansion (1914)	3229 N.W. Pittock Drive, Portland
Original Wasco County Courthouse (1859)	406 West Second Street, The Dalles
Jacksonville (town of Victorian houses and stores)	On Hwy. 38 west of Medford
Union (many Victorian houses, 1869-1907)	On Hwy. 203 southeast of La Grande

SPORTS

This chapter could have been called *Action* since sports and recreational activities are just that. But Oregon is full of opportunities, whether it's whitewater rafting on the Deschutes River, hang gliding along the coast, auto racing at Portland International Raceway, or your nephew's first grade school soccer game on the local playground. Freezing or panning action are your two options. Freezing action relies on fast shutter speeds and a keen awareness for firing the shutter at the peak moment of action. Panning with the action creates a greater sense of drama and movement and a streaked effect around your subject.

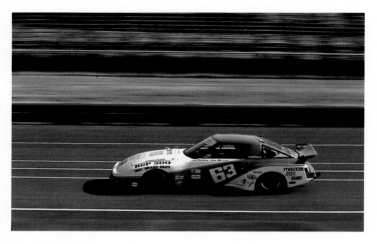

Opportunity Panning the action of race cars, water skiers, snow skiers, kayakers, soccer players, dune buggy riders, and rodeos. Frontlighting emphasizes detail.

Point of view and lens choice Position yourself so the action is parallel to the film plane and no obstructions exist between you and your subject. Strive for busy and colorful backgrounds. Unless you are on top of the action, use a 105mm or 135mm telephoto lens or telephoto zoom.

Exposure Set the shutter speed to 1/60-second. Adjust the aperture until a correct exposure is indicated. A shutter priority camera in automatic will do this for you. As the action speeds by you, left to right or right to left, move the camera in the same direction while following the subject, and take the picture. The result is a sharp car, skier, or kayaker, against a streaked background.

Film choice 100 ISO, color print; 100-64-50 ISO, color slide.

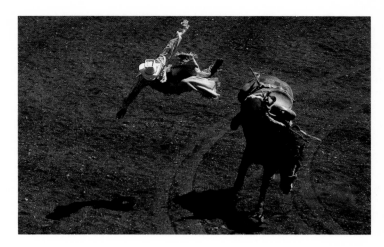

Opportunity Freezing the action of race cars, water and snow skiers, kayakers, soccer players, dune buggies, rodeos. Frontlighting emphasizes detail.

Point of view and lens choice Position yourself so the action is coming toward you or at an angle. Allow no obstructions between you and your subject, and avoid busy backgrounds. Kneel, forcing the action against the sky, or shoot from up high, placing the subject against the sand, snow, turf, or dirt. The 135mm or 200mm telephoto lens or telephoto zoom provide good shots.

Exposure Freezing action relies on a fast shutter speed — 1/250, 1/500, 1/1000. Match the speed to your subject. See additional tips. Adjust the aperture until a correct exposure is indicated. A shutter priority camera in automatic will do this for you.

Film choice 400-200 ISO, color print; 400-200 ISO, color slides.

Additional tips

- To freeze action, use a 1/250-second shutter speed when the action is coming toward you. Use 1/500 when the action is at an angle. Use 1/1000 when the action moves parallel to the film plane.

- Combining fast film with fast shutter speeds allows you to use small lens openings, f/11 or f/16. If you are not quite focused, the resulting f/stop picks up the loss of sharpness.

- Anticipate where the action may take place. Focus and set your exposure on the spot where you expect the action will take place, i.e. a bull and rider coming out of the chute, race cars entering hairpin turns, the goalie at the soccer game, the ridge at the top of the sand dune.

- If you have a winder or motor drive, use it. You may use more film, but film is cheap compared to the expense of a lost shot.

- If you are in-between action and you have a few frames left on the roll, change to a new roll. Running out of film during the next series of action is frustrating, particularly when it happens at a climactic moment.

- When using fast film, you may have difficulty panning at a slower shutter speed while maintaining a correct exposure. Use a neutral density filter to solve this problem.

Good shooting locations

Pendleton Roundup	In Pendleton the last week of September
St. Paul Rodeo	In St. Paul on the Fourth of July
State Fair and Rodeo	In Salem, during fair, last week of August
Sisters Rodeo	In Sisters during June
Hang gliding	At Cape Kiwanda, north of Pacific City
Dune buggies	At Siltcoos, south of Florence and Sand Lake
Automobile races	Portland International Raceway, Portland
Whitewater rafting	Deschutes, Rogue, and Snake rivers
Skiing	Mount Hood, year-round; Mount Bachelor, and Mount Ashland seasonally
Water skiing	Columbia and Willamette rivers
Hot air balloons	Sherwood

TECHNICAL INFORMATION CENTER

ISO/ASA film speed

- All film has an assigned film speed. Formerly this was called ASA, but now the term is ISO. Disregard this letter designation. Be concerned about the number that follows, i.e. 25, 50, 64, 100, 160, 200, 400.

 Think of these numbers as eyeballs, whose job is to gather light and record an image when the shutter opens. The more eyeballs the film has, the faster an image can be recorded. The fewer the eyeballs a film has, the longer it takes to record an image. The terms faster or longer refer to the shutter speeds you can use.

 A film with 400 eyeballs is a fast film, used primarily for stopping action or shooting under low-light conditions. Films with speeds of 100 or 64 are medium-speed films, primarily used for all-round picture-taking. Films with speeds of 50 or 25 are slow film, used when optimum sharpness and color saturation is wanted. Slow films, such as these, almost always require a tripod.

 When the film is processed, these eyeballs appear on film as grain specks. The more eyeballs the film has, the more grain specks appear on the print or slide. This is why the finished print or slide from fast film has a rougher quality than does medium or slow-speed films. The subject matter, therefore, determines which film speed to buy.

- For color prints the film speed choices are 100, 200, 400, or 1,000 ISO. For slides the film choices are 25, 50, 64, 100, 200, or 400 ISO. The decision to shoot slides or prints always is a personal one. Slide film records deeper colors, but you sacrifice the immediacy of a color print to share with friends. Slide film is less expensive to shoot than color print film, and you can have prints made from the slides.

- Whenever you load the film in the camera, you must tell the light meter how many eyeballs you are putting in the camera. Set the film speed dial to the correct number of eyeballs. If the film speed dial is set incorrectly, your exposures will be too dark or too light.

Aperture

- The aperture is located in the lens. It determines the area of sharpness in your finished picture. The aperture number you select determines the sharpness of the foreground and background. Apertures range from small numbers — f/2, f/2.8, f/4 — to big — f/11, f/16, f/22. **The bigger the number,** the bigger the area of sharpness from front to back. **The smaller the number,** the smaller the area of sharpness from front to back.

- Sometimes you want to emphasize one subject in the overall scene you are shooting. This is called a single theme picture, or isolating. To keep your subject isolated, you must use an aperture opening that isolates, one offering little sharpness in the foreground or background. Once again, use the smaller numbers. To further isolate subjects, use the telephoto lens. It has a narrow angle of view and, by its own design, offers a limited depth-of-field.

- Story-telling pictures show sharpness and detail throughout the scene, from foreground to infinity. Landscapes are the most common story-telling pictures. To create sharpness throughout the entire scene, use the bigger numbers, f/11, f/16, or f/22. These often are called landscape apertures. Wide-angle as well as normal lenses also produce good results. Because the wide-angle lens has great scope, it includes more of the story you are telling than do other lenses.

Shutter speed

- The main function of the shutter speed is to set the correct exposure. Your camera manual may not agree, but the writers of camera manuals often are not in the business of taking pictures. Only when you appreciate the value of the proper depth-of-field can you begin to understand why you should use the shutter speed mainly for exposure.

- If you want to freeze action or simulate motion, set the shutter speed first. Then adjust the aperture for a correct exposure.

Exposure on sunny days

■ The easiest compositions for which to set exposures are those which are frontlit or those in which the subjects fill the frame. Whether you meter in manual or in automatic, the indicated exposure is correct. The only exception is when the subject is white, i.e. churches, snow scenes, buildings, a bride. Set the exposure to one stop over the indicated reading, or use the gray card in the back of this book to make a correct exposure.

■ When shooting at midday, use a polarizing filter to reduce glare and improve color saturation. You can use a polarizing filter at other times of the day. But the sun must be at a ninety-degree angle to your subject.

■ Sidelit subjects require a one stop overexposed setting when you want to catch detail in the shadows.

■ Backlighting almost always produces a silhouette. A sunset is the most common situation for backlighting. If you want a correct exposure on subjects in front of the backlight, move in until the subject fills the frame. Then manually set the exposure. Back up, recompose, and shoot.

Exposure on cloudy or rainy days

■ When shooting landscapes under a dull gray sky, tilt the camera down so that the sky is not part of the exposure. Set the exposure, recompose, and shoot. If the camera does not have a manual exposure control, set the auto-exposure override to +1.

■ Use a polarizing filter to minimize the gray glare from landscapes, foliage, lakes, rivers, and streams. Because the sun is filtered through the sky, polarization occurs at almost any angle.

■ When shooting portraits or candids, use a warming filter, 81-A, to reduce the bluish cast that will result on the film. This applies to slide film only.

Using the depth-of-field scale to pre-focus your shot

■ The biggest f/stop number — 16, 22, or 32, depending on the lens — produces the greatest depth-of-field. The position of the distance scale determines the point in the foreground where sharpness begins and the point in the background where the sharpness ends.

1. Note the selection of the f/stop. It is f/22. There are two 22s on the scale: one on the far left and one on the far right. Just inside of each 22 is a slash. Imagine that these slashes continue as a straight line into the distance scale. Think of these as road blocks whose job it is to contain the distances placed within them and to make these distances sharp on film. What is the minimum distance and the maximum distance at which the sharpness begins and ends? Approximately twelve feet to infinity (∞). The maximum depth-of-field, however, has not been achieved.

2. Imagine again that these two slashes continue as a straight line into the distance scale. Think of these as road blocks. Once again, their job is to contain the distances between and make these sharp on film. When I move the scale so that the infinity mark rests just inside the left road block, I achieve greater depth-of-field than in example 1. (You may have a lens that focuses in the opposite direction. If so, move the infinity mark just inside the right road block.) What is the minimum distance contained by the right road block? A little less than six feet. By presetting your focus to the distance scale corresponding to the f/stop in use, you therefore know the maximum area of sharpness that will appear on the film. As an example, f/22 is six feet to infinity of sharpness that will appear on film.

Caution: When you have preset your focus, you may want to refocus because the scene appears fuzzy. This is because you are looking through the lens at its widest opening. After you shoot the picture, the lens will stop down to f/22, giving sharpness from six feet to infinity.

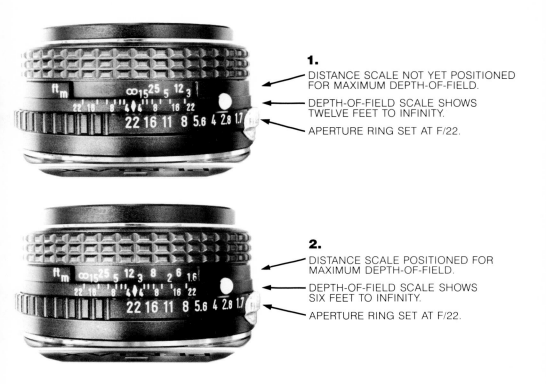

1.

DISTANCE SCALE NOT YET POSITIONED FOR MAXIMUM DEPTH-OF-FIELD.

DEPTH-OF-FIELD SCALE SHOWS TWELVE FEET TO INFINITY.

APERTURE RING SET AT F/22.

2.

DISTANCE SCALE POSITIONED FOR MAXIMUM DEPTH-OF-FIELD.

DEPTH-OF-FIELD SCALE SHOWS SIX FEET TO INFINITY.

APERTURE RING SET AT F/22.

Final note All single focal-length lenses — 50mm, 35mm, 28mm, 24mm, 85mm, 135mm, 200mm — have a depth-of-field scale. If you own one of these lenses, especially the 35mm, 28mm, or 24mm, you will find it invaluable when shooting landscapes. If you own a wide-angle or telephoto zoom — 28mm-85mm, 35mm-70mm, 35mm-135mm, 70mm-210mm, etc. — you probably do not have a depth-of-field scale.

You can make the entire composition sharp without a depth-of-field scale by using the following guide. At a wide-angle focal length of 28mm, focus approximately four feet into the scene, at a focal length of 35mm, focus approximately seven feet into the scene. At a telephoto focal length of 100mm, focus approximately seventy feet into the scene, and with a 200mm, focus approximately 150 feet into the scene.

Composition

1. For single subject pictures, shoot full-frame. Move close to the subject, or change to a telephoto lens.

2. When shooting landscapes, avoid placing the horizon line at the middle of the frame. The photograph should make a statement. Do you want to emphasize the sky or landscape? A low horizon, near the bottom third of the picture, emphasizes the sky. A high horizon line, near the upper third, emphasizes the foreground and receding landscape. Mirrored reflections splitting the horizon in half also make unique compositions.

3. Avoid overusing the horizontal frame. The world is full of natural verticals, i.e. trees, buildings, flowers, people. By placing vertical subjects in a vertical frame, you suggest growth, power, and strength.

4. Shoot the subject at its level to give the viewer a sense of participation in the photograph. In most cases, this means shooting from a low position, perhaps kneeling. In a few instances, you may need to shoot down from a high point.

5. Shoot landscapes with foreground interest to give the viewer a sense of participation. This creates depth, as well as invites the viewer into the picture.

6. Look for opportunities to shoot the masses. Too often the photographer sees only the whole scene, passing up the masses. Instead of shooting the turkeys and the barn, shoot the mass of turkeys. Instead of shooting the whole fruit stand, shoot an entire box of fruit. Instead of shooting the wheat field, shoot the shocks of wheat.

7. When you place your subject in a frame, you emphasize your subject. Windows are a common choice. But often photographers overlook using an out-of-focus foreground such as branches, doorways, or even other people in a crowd.

Note: Captions in this composition section are repeated with the photographs for your convenience.

1. For single subject pictures, shoot full-frame. Move close to the subject, or change to a telephoto lens.

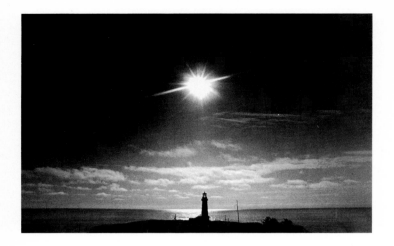

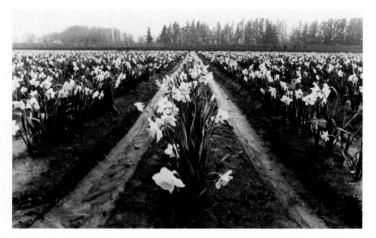

2. When shooting landscapes, avoid placing the horizon line at the middle of the frame. The photograph should make a statement. Do you want to emphasize the sky or landscape? A low horizon, near the bottom third of the picture, emphasizes the sky. A high horizon line, near the upper third, emphasizes the foreground and receding landscape. Mirrored reflections splitting the horizon in half also make unique compositions (right).

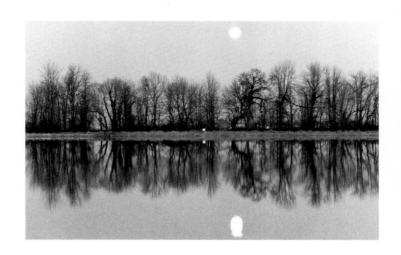

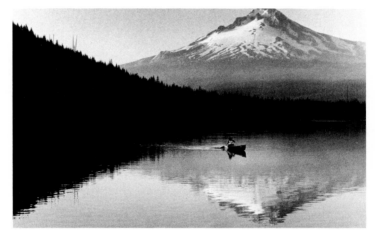

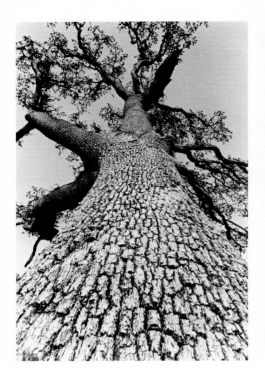

3. Avoid overusing the horizontal frame. The world is full of natural verticals, i.e. trees, buildings, flowers, people. By placing vertical subjects in a vertical frame, you suggest growth, power, and strength.

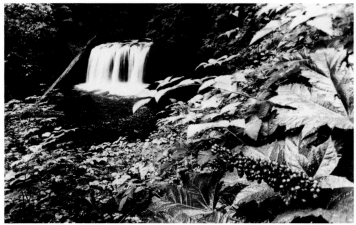

4. Shoot the subject at its level to give the viewer a sense of participation in the photograph. In most cases, this means shooting from a low position, perhaps kneeling. In a few instances, you may need to shoot down from a high point.

5. Shoot landscapes with foreground interest to give the viewer a sense of participation. This creates depth, as well as invites the viewer into the picture.

6. Look for opportunities to shoot the masses. Too often the photographer sees only the whole scene, passing up the masses. Instead of shooting the turkeys and the barn, shoot the mass of turkeys. Instead of shooting the whole fruit stand, shoot an entire box of fruit. Instead of shooting the wheat field, shoot the shocks of wheat.

7. When you place your subject in a frame, you emphasize your subject. Windows are a common choice. But often photographers overlook using an out-of-focus foreground such as branches, doorways, or even other people in a crowd.

Checklist for The Art of Seeing

- Is the film speed set to the correct ASA setting?

- What kind of picture do you want to take? For storytelling, use a wide-angle or normal lens at apertures from f/11 through f/32. For single themes or isolations, use a telephoto lens at apertures from f/2 through f/5.6.

- For close-ups, using necessary close-up equipment, when the subject is parallel to the film plane, use f/8. When the subject is at an angle, use f/16.

- What point of view conveys the message you want your viewer to receive?
Lying on your stomach?
Kneeling?
Lying on your back and shooting upward?

- Does the scene present possible exposure problems? Set for snow scenes at one stop over or use a gray card.

When an overcast sky or a waterfall makes up more than one-third of the composition, set the exposure to one stop over the indicated reading.

When using a telephoto lens at sunrise or sunset, take the reading to the right or to the left of the sun.

When the background is brighter than the subject in front, move up to the subject and take the meter reading directly from the subject — unless you want a silhouette.

- Have you selected the right composition?
Is the scene a natural horizontal?
Is the scene a natural vertical?
Is the horizon line straight?
Are you close enough?
Are you too close?

If interest is focused above the horizon line, have you placed the horizon line near the bottom third of the frame? If interest is below the horizon line, have you placed the horizon line near the top third of the frame?

- Remember to ask these questions:
Will a polarizing filter reduce the glare? Will a neutral density filter help maintain a correct exposure?

Checklist for the gray card

- Use the gray card (on next page) for these difficult exposure problems:

 1. Snow, white sand beach or open water compositions.

 2. Dark subject against a dark background.

 3. Dark subject against a bright background.

- Position card in the same light, and at the same angle to the light, as the subject in your composition.

- Hold card so that it fills your frame and meter reads only light reflected from the card, but do not hold too close to camera or you will shade card.

- Do not meter glare from card, change card angle slightly to avoid glare.

- Card reflects about eighteen percent of the light falling on it, which is the average calibration for your light meter.

Acknowledgements

The photograph on page 42, Eagle Cap Wilderness Area, is © Gary Braasch, and the photograph on page 79, rodeo rider and horse, is © Photounique/David Barnes. I thank them for permission to reproduce these photographs in this book. Also thanks to Dale Smith for the expedient darkroom work for the black and white photographs in this book.